How to

Paint
like
Turner

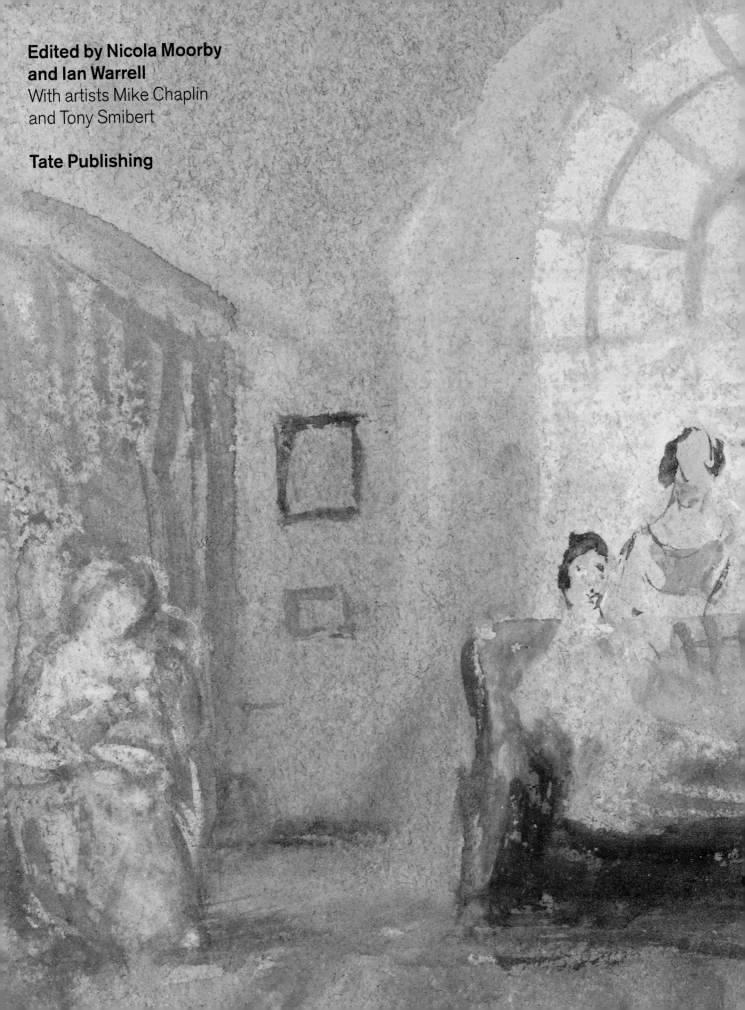

**Edited by Nicola Moorby
and Ian Warrell**
With artists Mike Chaplin
and Tony Smibert

Tate Publishing

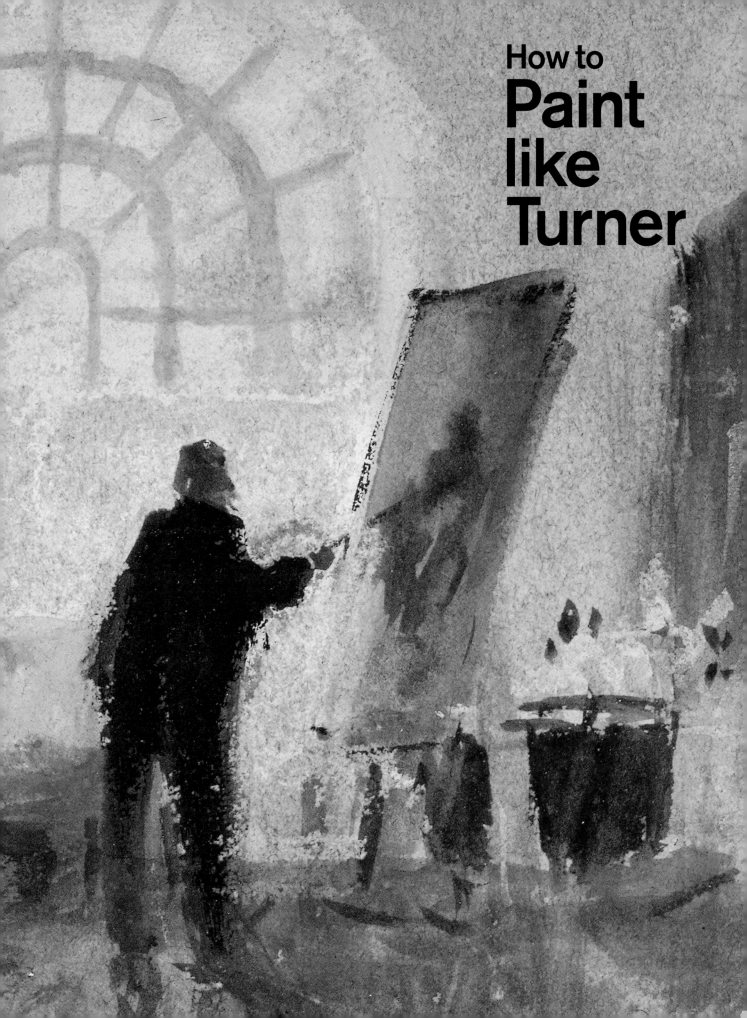

How to
Paint like Turner

First published 2010 by order of the Tate Trustees
by Tate Publishing, a division of Tate Enterprises Ltd,
Millbank, London SW1P 4RG
www.tate.org.uk/publishing

A catalogue record for this book is available from the British Library

ISBN 978 1 85437 883 5

Distributed in the United States and Canada by
Harry N. Abrams, Inc., New York

Library of Congress Control Number: 2009941717

Designed by Rose
Printed and bound in China by C&C Offset Printing Co., Ltd

Cover:
Mike Chaplin painting a copy of J.M.W. Turner's *The Scarlet Sunset*
(see pp.116–19)

Frontispiece:
J.M.W. Turner, *The Artist and his Admirers* 1827 (detail),
watercolour and bodycolour on paper, 13.8 x 19, Tate

Pages 6–7:
J.M.W. Turner, *Richmond Hill* c.1820–5 (detail), watercolour and
bodycolour on paper, 29.7 x 48.9, National Museums Liverpool
(Lady Lever Art Gallery)

Measurements of artworks are given in centimetres,
height before width.

Contributors:
Nicola Moorby: NM
Jacob Thomas: JT
Joyce Townsend: JHT
Ian Warrell: IW

Contents

'Copy first the works of God,
and then the works of Turner.'

Edward Lear

Foreword

Left:
J.M.W. Turner
The Blue Rigi, Sunrise 1842
(detail)
Watercolour on paper
29.7 x 45
Tate

Recently, at the adult education art group that I regularly attend, it was suggested by the teacher that for the following week we should find reference material with the view to creating our own abstract painting. Being a watercolour artist with an eye for detail, abstraction is not my preferred form of painting. However, my great-great-uncle, J.M.W. Turner, came to my rescue. I have always found you can learn so much from studying his work and on this occasion I decided to create my own version of one of my favourite pictures, *The Blue Rigi, Sunrise* (left and p.105). I know Lake Lucerne in Switzerland well and have seen for myself the magic of the colours and moods of the Rigi Mountain beside the lake. With the aid of a postcard reproduction, I set to work. Although my first point of inspiration was Turner's famous watercolour, I was not making a strict copy. Instead, I used my own photographs to create a strong composition with the mountain at the centre. The colours were based upon my imagination and memory. However, I studied Turner's distinctive method of applying paint carefully and used a similar technique to create soft, abstracted forms. The addition of a boat and some birds in the foreground provided a final 'Turneresque' detail.

When my art master came to view my work, his comment was 'you can't go wrong when you take a lesson from the Old Masters'. Studying the works of Turner is a great way to learn and develop. I hope this book helps you to find the same rewards and sense of personal achievement.

Rosalind Mallord Turner

Getting
to Know
Turner

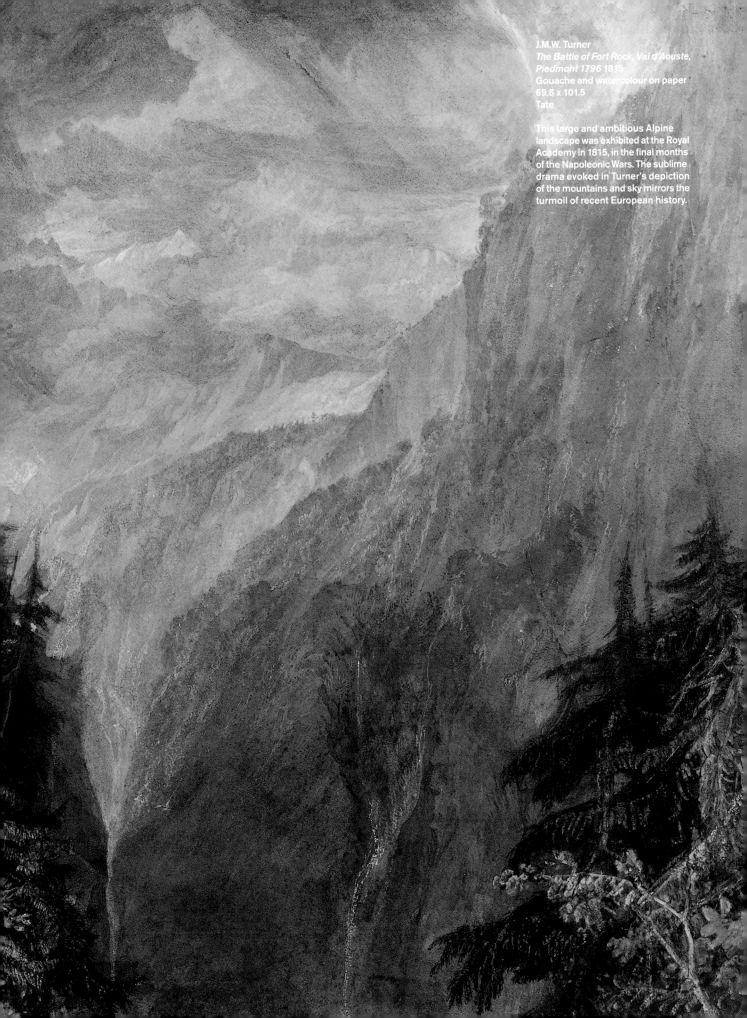

J.M.W. Turner
The Battle of Fort Rock, Val d'Aouste,
Piedmont 1796 1815
Gouache and watercolour on paper
69.6 x 101.5
Tate

This large and ambitious Alpine
landscape was exhibited at the Royal
Academy in 1815, in the final months
of the Napoleonic Wars. The sublime
drama evoked in Turner's depiction
of the mountains and sky mirrors the
turmoil of recent European history.

Introduction

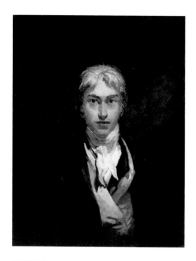

J.M.W. Turner
Self-Portrait c.1799
Oil on canvas
74.3 x 58.4
Tate

Probably painted on the occasion of his election as an Associate of the Royal Academy in 1799, Turner's only adult self-portrait shows a well-dressed young man with an intense, self-assured gaze.

J.M.W. Turner (1775–1851) is one of the giants of art history. Unquestionably one of the greatest painters of landscape the world has ever seen, his work bridges the gap between the classical perfection of the Old Masters and the progressive movements of the modern era such as Impressionism and Abstract Expressionism. Although his name has become synonymous with the use of dazzling colour, experimental form and daring conceptual innovation, his professional life encompassed an astonishing breadth of activity, exploring themes from history, classical mythology, literature and contemporary events, all of which he explored through his chosen genre of landscape. Above all, he is celebrated for his creative approach to the problem that dominated his life's work, the effective depiction of light.

Turner was a most versatile practitioner, proficient in drawing, painting and printmaking. He was as comfortable producing tiny book illustrations as large exhibition canvases, and it was this diverse range of skills, combined with his prodigious talent and boundless ambition, which formed the basis for his phenomenal success as an artist. What really set him apart from other artists, however, was his original and inventive approach to technique. Turner's methods were unique. He refused to be restricted by conventional working practices and instead followed the dictates of his imagination. As his friend, the artist and diarist Joseph Farington, put it, he had 'no systematic process' when painting, but constantly varied his tactics until he reached a solution that 'expresses in some degree the idea in his mind'. This technical ingenuity was evident in his use of oil paint,

particularly his willingness to try new products, and the unorthodox way in which he manipulated and applied pigment. However, his most progressive achievements were developed and sustained in his watercolour paintings, in which he not only forged new systems of painting, but actually transformed the very appearance and status of the medium itself. More than any other artist, he mastered a synthesis between its intrinsic characteristics and the effects that it could achieve, and this led the way in establishing watercolour as an autonomous, expressive art form. His paintings are revered as the pinnacle of accomplishment within the field, and continue to represent the standard against which watercolour artists are measured today.

About this book

According to Turner himself, the only secret to his artistic success was 'damned hard work'. This book is intended to offer a rather more considered guide to the techniques and methods that underpin his work. It discusses the materials favoured by Turner during his lifetime and offers advice for the modern artist on finding suitable alternatives. Step-by-step demonstrations deconstruct some of his most commonly used watercolour techniques, while practical exercises based upon his approach offer insights that provide a starting point for individual creativity. The book is not intended to teach you merely how to copy his work, but also offers systems for developing your own painting technique in new and exciting ways. The most important lesson to be learned when painting like Turner is that art is about freedom of expression. As he himself said, no matter how much the artist takes from the world around him, creativity is 'a stream that forces a channel for itself'.

Life

Turner's story begins in Covent Garden, London, where he was born in April 1775. His father was a wig-maker and barber, and Turner's earliest drawings were displayed in the window of his Maiden Lane shop. It soon became clear, however, that the boy was destined for greater things, and at the age of fourteen Turner was enrolled in the Royal Academy Schools to embark upon the requisite education of the professional artist. During the late eighteenth and early nineteenth centuries, the Royal Academy played a vital role in the training of contemporary artists. It was the institution where artists studied, taught, exhibited and socialised, and Turner would remain involved with it for the rest of his life. It took him just ten years to graduate from student to Associate, and in 1802 he was elected a full Academician, the youngest artist ever to hold the position. He quickly established a name for himself as a painter of topographical views, and his early work is notable for its precocious mastery of subject and his penchant for naturalistic effects. He exhibited and sold both oils and watercolours, but it was the latter that were considered to be the most advanced and technically superior examples of their day.

In 1807, Turner was appointed Professor of Perspective at the Royal Academy, delivering lectures on the subject for more than twenty years. His interests should have earned him the job of Professor of Landscape, but in the nineteenth century such a post did not exist. Despite his loyalty to the Academy, he was not beyond subverting its authority in artistic matters. In 1804, frustrated at the limited opportunities for showing his paintings, he became one of the first artists to open his own private gallery to display his works. As his art matured, he demonstrated an increasing desire to challenge the accepted hierarchies, which prioritised historical subjects over landscape, and oil painting over watercolour. Although he continued to produce watercolours that were essentially topographical in nature, his

original and virtuoso use of the medium elevated his views beyond mere description of place. Drawing on his own observations of the world, he painted landscapes glowing with atmospheric effects described through colour and form. His ambition knew no bounds and his watercolours reached heights of visual spectacle and emotional depth more usually associated with oil painting (see pp. 10–11).

Turner also attempted to revolutionise the genre of landscape painting. In defiance of traditional theories, which asserted that landscape painting involved a mere recording of nature, he set about demonstrating that it could be a powerful and cerebral art form. In his hands, views with a biblical or mythological flavour acquired levels of meaning and drama to rival the most epic history paintings, and domestic pastoral locations such as the River Thames were recast as Arcadian idylls in the manner of Old Masters such as Claude Lorrain (c.1604/5–82). Turner formalised his doctrine in a published sequence of engravings, known as the *Liber Studiorum* (1807–19). Comprised of more than eighty images illustrating six different categories of landscape, the series represents a complete visual manifesto for the advancement of the genre. It was this multifaceted outlook that led his contemporary and fellow watercolourist, John Constable (1776–1837), to describe him as having a 'wonderful range of mind'.

Unlike Constable, who struggled to make a living from his art, success came easily to Turner. He became a wealthy man, earning enough to finance a second home built to his own design outside London in Twickenham, close to the River Thames. Although an early love affair led to the birth of two daughters, he preserved his independent status, living as a bachelor with only his devoted father for company (right). In contrast to Constable, who lived and worked in his native Suffolk, Turner was a restless soul who sought inspiration away from home. He had an insatiable thirst for travel. Other artists of

John Linnell (1792–1882)
Portrait study of J.M.W. Turner's father, with a sketch of Turner's eyes, made during a lecture 1812
Pencil on paper
18.7 x 22.5
Tate

Turner's father, William Turner, played an important supporting role in his son's professional life, grinding paints, preparing canvases and staffing Turner's private gallery in Harley Street in central London. He died in 1829 when Turner was 54.

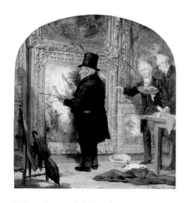

William Parrott (1813–69)
*J.M.W. Turner at the Royal Academy,
Varnishing Day* 1846
Oil on canvas
25.1 x 22.9
Museums Sheffield

Turner was the first artist to use Varnishing
Days as an opportunity to add further paint
to a picture prior to the opening of an
exhibition. Sometimes his efforts ensured
that his work stood out in comparison to
those of his rival exhibitors.

his generation may have ventured further
afield to the Americas, the Antipodes, or
the Middle or Far East, but no one else
travelled more widely or more frequently
within Europe and the British Isles. In his
twenties he established a pattern of
working that continued throughout his life,
embarking on a sketching tour during the
summer that provided him with enough
material to make finished works through
the winter months. In addition to making
the traditional artistic pilgrimages to Paris
and Italy, he navigated more unfamiliar
territories, exploring picturesque terrain
such as the remoter reaches of Wales and
Scotland, the Alps and the rivers of France
and Germany. His standard method of
working during his travels was to record
his observations in sketchbooks, which
could easily be carried around with him
and could then form the basis for more
developed paintings. The portable nature
of watercolour meant that it was a more
accessible medium for the travelling artist
than oil paints. While Turner rarely
painted outside, directly from the subject,
watercolour proved a useful tool for tonal
and colour additions to his pencil studies.
Back at home in the studio, the material
accumulated during these sketching
campaigns provided a basis for finished
compositions. Turner was a shrewd
businessman who recognised the
demands of market forces. To increase
public exposure of his works he diversified
into the lucrative market for black and
white prints. Much of his output was
devoted to the production of engraved
pictorial series that catered to the
tastes of the armchair tourist such as
Picturesque Views in England and Wales
(1827–38) or *Turner's Annual Tour* of the

Loire and Seine rivers (1832–5). Book
illustrations for popular authors such as
Samuel Rogers, Lord Byron and Walter
Scott also made him a household name
in his own lifetime.

Despite these commercially profitable
activities, Turner's commitment to
independent, original artistic practice
remained paramount and he was not
afraid to produce challenging work, which
invited a considerable amount of criticism.
During 'Varnishing Days', the time set
aside for minor adjustments prior to the
opening of the annual Royal Academy
exhibitions, he became known for dramatic
and eccentric last-minute reworkings
of a canvas, rather, as one commentator
put it, like 'a magician, performing his
incantations in public' (left). Increasingly
his landscapes exhibited an indistinctness
that his contemporaries failed to
comprehend. Although to a modern
audience his most pioneering paintings
are those where the haziness and
intangibility of his technique provides
a perfect vehicle for the insubstantiality
of a subject, those same paintings, such
as *Snow Storm – Steam-Boat off a
Harbour's Mouth* (opposite), were derided
by contemporary critics for their
unfinished appearance. Indeed, it was
widespread negative criticism of this
picture that inspired the artist and writer,
John Ruskin (1819–1900), to champion
the artist in his famous polemical
publication, *Modern Painters* (1843).
Yet although Turner's oil paintings began
to stack up unsold in the studio,
appreciation of his watercolours remained
undiminished. In later life, his search for
inspirational scenery took him to

Switzerland, where the combination of mountains, lakes and soft light provided him with the ideal subject for his vision. Late Swiss watercolours such as *The Blue Rigi, Sunrise* (see pp.8 and 105) are essays in melting form and colour, transforming the art of landscape from the earthly to the realms of the metaphysical.

Turner also finally found peace at home. In the 1830s he discovered the pleasures of Margate, a seaside resort on the Kent coast whose unrivalled expanse of shoreline provided an ideal retreat from London. He found a boarding house near the pier that not only offered the perfect spot for observing the changing beauties of sea and sky, but also had a congenial and attractive landlady, Mrs Sophia Booth, twenty-three years his junior. She became Turner's full-time companion, eventually moving with him permanently to Chelsea, where she acted as wife, housekeeper and studio assistant until the end of his days. She recalled his habit of rising early to witness the sunrise on the Thames and described his long

working hours; he would even request drawing materials in the middle of the night when sleep eluded him.

Turner died in 1851. In 1775, few people witnessing his christening in his local church of St Paul's, Covent Garden, would have guessed that this baby would become one of the most celebrated names in the history of art. Yet seventy-six years later, he was laid to rest in the crypt of St Paul's Cathedral, as one of the great men of his age. His most enduring monument, however, is not to be found within Christopher's Wren's famous edifice, but rather a couple of miles upriver at Tate Britain, the home of the Turner Bequest. After Turner's death in 1851 complications with his will led to the transfer to the nation of the entire contents of his studio. Comprised of hundreds of oil paintings, sketchbooks, and many thousands of drawings and watercolours, the Turner Bequest represents a unique artistic legacy and an insight into the working practices of a true genius of art. NM

Below:
J.M.W. Turner
Snow Storm – Steam-Boat off a Harbour's Mouth exh.1842
Oil on canvas
91.4 x 121.9
Tate

This was one of Turner's most controversial paintings, with critics lampooning its portrayal of wind and water, and asserting that it was nothing but a mass of 'soapsuds and whitewash'. John Ruskin, however, defended the work. He described it as 'one of the very grandest statements of sea-motion, mist and light that has ever been put on canvas', adding, 'of course it was not understood; his finest works never are'.

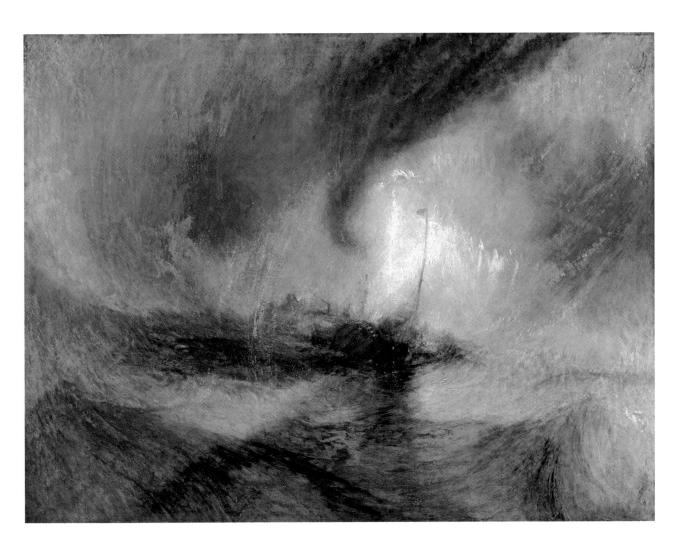

Turner's Training

This book is about learning how to paint by studying the work of another artist, a didactic exercise of which Turner himself would have thoroughly approved. His own artistic training was undertaken in a number of different ways. As a student at the Royal Academy Schools he followed a set curriculum of drawing from plaster casts of antique statues (right, bottom). When he gained sufficient proficiency in rendering musculature and figurative poses, he progressed to the Life Class, which offered further practice in drawing, but this time from living human models. This course of study succeeded in teaching a high standard of draughtsmanship as well as a thorough understanding of the human form. What was missing from the curriculum, however, was any schooling in how to paint, which was considered to be too manual a craft to be taught at such a distinguished academic level. Turner was obliged to find instruction from other quarters, and one way of doing this was to copy from the work of established artists. His study of stonework from the gateway at Battle Abbey, for example (right, top), is a colour exercise derived from an earlier watercolour by the eighteenth-century topographical painter, Michael Angelo Rooker (1746–1801). Using part of Rooker's composition as a starting point, Turner has perfected the process of building up a picture using one application of colour at a time, gradually moving through a scale of tonality from light to dark.

During the 1790s, Turner met Dr Thomas Monro, a physician who specialised in the treatment of mental illness. Chief among his clients was King George III, but one of his less illustrious patients was Turner's own mother, whose incurable psychological problems led her to be committed to the Bethlem Hospital (the notorious Bedlam) in 1800, where Monro was a leading practitioner. Her affliction must have been a perpetual dark cloud over Turner's adolescence, yet the silver lining in the situation was Monro's extensive collection of drawings, prints and watercolours, which he made accessible to the budding artist. For many years, Turner and his fellow art student, Thomas Girtin (1775–1802), broadened their knowledge of pictorial composition and paint effects by close examination of these works. One artist in particular whom they admired was John Robert Cozens (1752–97), and Dr Monro paid the two youngsters two or three shillings a week and a supper of oysters, to produce copies after the originals. It was from Cozens's Swiss and Italian views that Turner learned to create evocative and atmospheric scenes through soft and limpid watercolour washes.

Some of the best opportunities for study in Turner's life resulted from foreign travel. In 1802, he made his first trip to the Continent and was drawn like a magnet to the Louvre in Paris where he encountered at first hand the work of the Old Masters. In a small pocket sketchbook he made colour and chiaroscuro copies of paintings by some of the greatest painters of all time: Raphael, Titian, Rubens, Rembrandt and Poussin. He backed up his visual records with written comments which analysed how these heroes of painting used colour and expressive handling to achieve their goals. NM

J.M.W. Turner
An octagonal turret and battlemented wall: study of part of the gateway of Battle Abbey, after Michael Angelo Rooker 1792–3
Pencil and watercolour on paper
17.2 x 14.6
Tate

J.M.W. Turner
Study of a Boy Drawing; and an Antique Head ?1790–3
Chalk on paper
33.8 x 27.4 cm
Tate

Turner's Library

Turner's drive for self-directed learning never ceased. Over the course of his lifetime he built up a large reference library of books and visual material, which he could dip into for information on all manner of subjects. Unsurprisingly, as a result of his professorship at the Royal Academy he purchased many treatises on perspective, but he also owned several practical and theoretical manuals on art, such as Charles Antoine Jombert's *Méthode pour apprendre le dessin* (*Method for Studying Drawing*) of 1755. Since Turner's French seems to have been limited to basic tourist phrases, it was clearly the illustrations rather than the text that captivated his attention, and he made a number of anatomical studies based upon plates in the book. Later in life he acquired an English translation of Johann Wolfgang von Goethe's seminal *Farbenlehre* (*Theory of Colour*), published in 1840, which stimulated his thinking about the emotional impact upon the viewer of colour contrast within paintings. Goethe even provided the inspiration for two exhibited canvases, *Shade and Darkness – the Evening of the Deluge* and *Light and Colour (Goethe's Theory) – the Morning after the Deluge – Moses Writing the Book of Genesis* (both Tate), exhibited at the Royal Academy as a pair in 1843.

Instructive manuals devoted to watercolour technique began to appear from 1800 although they are conspicuously absent from Turner's shelves. By this date he was already an expert practitioner in the medium and is unlikely to have been interested in the basic level of guidance aimed at an amateur audience. Instead he seems to have been keen on books that

dealt with materials. Pierre Joseph Macquer's *Elements of the Theory and Practice of Chemistry* (1764), for example, may have helped him to understand the behaviour of substances such as gum arabic used in painting. Judging by the well-thumbed pages and the copious annotations written on the fly leaves, one of his favourite volumes was *The Artist's Assistant in the Study and Practice of Mechanical Sciences* (c.1785; right). This compendium provided information on equipment and processes for every practical art and craft form, from oil painting to papier mâché, but perhaps the most useful chapter was on colour. Before ready-made tubes of paint became available in the mid-nineteenth century, artists often had to mix their own paints. Different colours were made from different substances, and it was therefore helpful to know the raw ingredients of each one and to understand their individual strengths and weaknesses. For example, ultramarine, made from lapis lazuli, provided the most intense and stable hue, but was very expensive, whereas indigo, made from plants, was cheaper but inferior in brightness and less durable. Turner never slavishly followed rules propounded by anyone, but books such as these would have given him the confidence to experiment, as is demonstrated in his *Chemistry and Apuleia* sketchbook dating from 1813, which contains several recipes and notes for making pigments and varnishes.
NM with Rosalind Mallord Turner

Frontispiece to *The Artist's Assistant in the Study and Practice of Mechanical Sciences,* c.1785, from Turner's library
Private collection

Turner as Watercolourist

By the end of his life Turner was generally considered more than a little eccentric. His oil paintings had been routinely mocked since the 1820s, and only rarely found buyers. Yet throughout this period, he remained perhaps the most prolific and successful watercolour painter in London, and was frequently celebrated as the 'father' of this supposedly uniquely British school of art. While his works on paper had always proved saleable, he had first been able to savour the tide of public approval for his achievements as a watercolourist in 1819, when his friend Walter Fawkes staged an exhibition of his collection, including more than forty of the very finest examples Turner had created up to that date (right). The response was overwhelmingly positive, with critics praising Turner's ingenuity in the medium, and hailing him as an 'astonishing magician'.

This sense of amazement about the distinctive appearance of Turner's watercolours was evident even when he was a student at the Royal Academy in the 1790s. As each year rolled by, his works gained in scale and ambition, and were characterised by expressive realisations of atmospheric effects and an astonishing technical accomplishment. Aware that something new was afoot, his contemporaries quizzed him about his processes. But Turner was not about to share his hard-won innovations and, presumably in an attempt to fob off enquiries, was reported as claiming he had 'no settled process but drives the colours about till he has expressed the idea in his mind'. At this point, some collectors were inclined to think his work too fussy and detailed compared with

that of fellow watercolourist Thomas Girtin, but it was not long before Turner too adopted the breadth and lightness that made his friend's works so striking. The most uniquely Turnerian quality of these early works was his ability to retain or introduce brilliant highlights, something he achieved through a variety of means: drawing out colour with breadcrumbs or blotting paper; reserving lighter areas by stopping-out with gum arabic; or scratching the painted surface to reclaim the underlying white sheet, a technique for which he specifically kept his thumbnail sharpened like an 'eagle-claw'.

All of these skills came into play for the groundbreaking watercolour series of the Alps he painted in the years after his first tour of the Continent in 1802. Very few earlier artists had addressed this spectacular scenery with such purpose, and none had produced anything of such extraordinary visionary drama in the medium of watercolour. While there is some truth to the perception that Turner was aspiring to paint works on paper with the power of oil painting, he seems also to be defiantly demonstrating the unique possibilities of watercolour, featuring glimpses of snowy peaks or dissolving rainbows, nuanced layers of different coloured washes for expanses of rock face, and a surface alive with eye-catching details. It is hardly surprising that this series remains one of his major achievements as an artist.

During the years before he was able to return to mainland Europe, Turner embarked on several publishing projects, focusing on different areas of the British

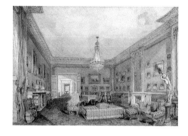

J.M.W. Turner
Drawing Room of 45 Grosvenor Place 1819
Watercolour and pen and ink on paper
15.2 x 21.6
Private collection

Turner's watercolour depicts the scene in Walter Fawkes's London home during the exhibition there in 1819. Around the walls are the highlights of the collection – forty watercolours by Turner himself.

landscape. After Cornwall, Devon and the Sussex coast, he went on to produce views of Yorkshire and the Scottish borders. Each of these subjects is a distillation of Turner's experience of an actual place, worked up from terse pencil outlines to a complex resolved image, infused with light, atmosphere and the presence of humanity. The seemingly effortless freshness of these watercolours disguises the rigorous planning stage that lies behind them. For, between the pencil sketches and the finished watercolours, Turner evolved a creative process that enabled him to experiment in an open-ended fashion with the structure and relative dispositions of colour and light. Since he very rarely worked on the spot in colour, this was his way of digesting his observations of the natural world before he reshaped them for public consumption. The watercolour studies he produced during this stage are generally known as 'colour beginnings', and have become a popular aspect of Turner's work in their own right, even though they would never have been seen as worthy of public scrutiny by the artist or his contemporaries. There are many hundreds of studies of this kind in the collection at Tate, some of them evidently painted across one sheet of paper, which was only afterwards cut into individual images. Turner liked to revert to the scale practice that he had learned as a young man, building his images up in

batches by applying one tone where it was needed in each design before moving on to the next, allowing each to dry in turn, sometimes with at least four evolving at the same time. The process can be detected in two studies of a sunset (or it may be a sunrise) over a river, where one is slightly more advanced than the other (below). One charming account recalls how Turner would hang up his moist studies on cords spread across his room, so that his drying sheets, stained with 'pink and blue and yellow', would at first glance resemble the laundry of a washerwoman.

Another well-known anecdote describes how Turner painted a remarkable watercolour of a man-of-war, or warship, in just a morning, during a stay at the Yorkshire home of Walter Fawkes: 'He began by pouring wet paint onto the paper till it was saturated, he tore, he scratched, he scrubbed at it in a kind of frenzy and the whole thing was chaos – but gradually and as if by magic the lovely ship, with all its exquisite minutiae, came into being.' Astonishing magic indeed. But a pair to this watercolour, showing a wrecked East Indiaman, which is based on one of the colour beginnings, reveals that Turner was only able to create with such finesse and showmanship because he had a sure idea of what he intended to achieve, a result of diligent preparation. This is not to

suggest that he did not exploit accidents as he resolved his image. Another privileged first-hand observer recalled that 'His completing process was marvellously rapid, for he indicated his masses and incidents, took out half-lights, scraped out high-lights and dragged, hatched and stippled until the design was finished'.

To the modern eye, there does not seem to be a huge stylistic shift between the watercolours Turner was producing in the 1820s and 1830s (for projects such as *Picturesque Views in England and Wales*), and the sets of late Swiss watercolours, created between 1842 and 1845 (see pp.8 and 105). Though both groups are now widely prized as some of the finest watercolours ever painted, the latter were at first suspiciously considered somehow different. The content of the images is possibly simpler, relying more on a unifying effect than on topographical incident, but Turner evidently felt able to enrich his technical process by augmenting his washes with delicate touches of his brush to create sophisticated patterns, at once part of the image, but also suggestive of something more abstract. In developing these great final watercolours, Turner set a daunting standard that was a glorious recapitulation of a career with so many innovative highs, providing an example that continues to inspire. IW

Below left:
J.M.W. Turner
The River: Sunset c.1820–30
Watercolour on paper
30.5 x 49
Tate

Below right:
J.M.W. Turner
River with Trees: Sunset c.1820–30
Watercolour on paper
30.4 x 48.8
Tate

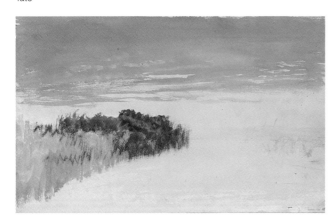

Turner as Teacher

The idea of learning from Turner's work is not new, and can be traced back in various ways, to John Ruskin in the later nineteenth century, and before that to Turner himself. As a young artist, he was always alert to potential methods of establishing his financial independence, as well as ways of generating recognition for his name. With these ends in mind, when he was not yet twenty, he had already offered his services as a 'drawing master', and quickly attracted a clutch of pupils. Turner was not alone in supplementing his artistic aspirations as a drawing master. It was an essential element of the work of many other great British watercolour painters, including Paul Sandby, Alexander Cozens, Francis Towne, Thomas Girtin, David Cox and John Sell Cotman. All of Turner's pupils copied watercolours that he made specifically for this purpose, examples of which can be found in the Turner Bequest at Tate. Some of these are fully coloured, but others are simple blue and grey wash drawings, intended to provide the foundations for an understanding of chiaroscuro (the contrast of light and shade).

A note in Turner's *Marford Mill* sketchbook, used in 1794, records his commitment to give someone called Major Frazer a series of eight lessons, each lasting an hour and a half. For this he apparently charged 5 shillings – hardly a negligible sum at that time, though before Turner gave up teaching a few years later he had raised his rates to 7 shillings and 6 pence. Major Frazer is possibly typical of those in the military services, who sought instruction from a drawing master in order to be able to record topography and draw maps

accurately. More usually, however, an artist's pupils were likely to be young ladies, like those who inhabit the novels of Jane Austen or Charlotte Brontë, many of whom were expected to acquire the 'accomplishment' of painting as one of a portfolio of assets with which to burnish their stock on the marriage market. In Turner's case, we know of at least ten other named pupils, although only three of these were women. The most notable was Julia Bennet (1775–1867), later Lady Willoughby Gordon, who remained a friend and eventually acquired a group of three oil paintings by Turner. In one of these he paid her the compliment of working directly from her own design.

Another important student was the Revd Robert Nixon (1759–1837), an amateur artist based near Sidcup, Kent, who is credited with spotting Turner's precocious early watercolours on display in his father's barber shop. Despite being significantly older than his discovery, Nixon subscribed for lessons, and also managed to entice Turner to accompany him on a tour of Kent in April 1798. Their journey took them to Allington Castle, near Maidstone, where Turner sketched the ancient gateway. He perhaps undertook this subject deliberately in order to offer further guidance to Nixon, who had sent him his own monochrome sketch of the entrance a couple of months earlier (opposite). Turner had then been unable to conduct his usual lesson in person because of a fall, which had injured his leg. Instead, he annotated Nixon's study with suggestions on how to improve the shadows in the image (and the standard fee was, most probably, still expected).

By the end of that year Turner was already complaining that he was 'determined not to give any more lessons in drawing', presumably finding the demands on his time a distraction from the pursuit of his own work, which was increasingly sought after. Though he retained some students for another year or so, the didactic element of his character did not find a suitable outlet again until 1811, when he delivered the first of a series of six annual lectures as Professor of Perspective at the Royal Academy. Despite researching the science of perspective diligently, it is clear that Turner hoped to inspire his students towards a much broader application of its principles by focusing on the importance of landscape in general in his opening lecture. Regrettably, Turner's talks were muddled and largely inaudible. However, the illustrations he created to accompany them proved a great success. This follows the pattern of his earlier teaching role, where he was temperamentally best able to demonstrate how to achieve an effect by example, rather than by describing it.

Someone who was much better equipped to write about the processes of drawing and painting was John Ruskin. The son of a wealthy wine merchant, he studied first with drawing masters, such as Anthony Vandyke Copley Fielding and James Duffield Harding, but was a fervent admirer of Turner's works, primarily his watercolours, and quickly built up a formidable collection. From his careful scrutiny of these treasures, he set out to champion Turner as the foremost artist of the age, believing that in his works the art of watercolour had reached its zenith.

A few years after Turner died in 1851, Ruskin took on the task of arranging for public display selections from the vast body of works on paper that had passed to the nation. This was a labour of love, since the official view was that the collection was an encumbrance, of little use to anyone. Ruskin, by contrast, saw its potential as a teaching resource, recognising how professional and amateur artists could benefit from being able to study Turner's preliminary sketches, as well as his fully finished paintings. Yet Ruskin, too, had his blind spots in matters of taste, and labelled many of the atmospheric studies so readily appreciated today as 'rubbish', 'worse' and 'useless'. What was valuable to him was not the aesthetic appeal of a study, but what it might reveal about Turner's methods. (Nearly twenty years later, a new generation, including James McNeill Whistler, began to appreciate these private experiments for their intrinsic qualities.)

In many of his writings, particularly *The Elements of Drawing* (1857), Ruskin exhorted his readers to take pains to copy Turner's watercolours, by then on display at London's National Gallery. He included lists of approved examples, notably many of the designs for *Liber Studiorum* (1807–19), but his catalogues of the Turner Bequest also assumed an instructive tone that persuaded countless artists to take up the challenge of measuring themselves against Turner's achievement. The most exceptional of these was William Ward (1829–1908), a clerk in the City, who was able to replicate a wide variety of Turner's designs with unerring accuracy (see p.97). Other known copyists include Isabella Lee Jay (*fl.*1882–96), Albert Goodwin (1845–1932) and the important collector of Turner watercolours Henry Vaughan (1809–99). A slightly different approach was adopted by Hercules Brabazon Brabazon (1821–1906), who produced what he called 'souvenirs', loosely based on Turner's originals (below). This tradition of working from Turner's images has continued right up to the present day, and is something you can try for yourself, either in the Print Room at Tate Britain* or by working from the examples in this book. IW

Left:
Letter from Revd Robert Nixon to Turner, with a view of Allington Castle, Kent, annotated with comments by Turner, 1798
Tate Archive

Top right:
J.M.W. Turner
The Rham Plateau, Luxembourg, from the Alzette Valley c.1839
Gouache, pen and ink and watercolour on paper
14 x 19.3
Tate

Bottom right:
Hercules Brabazon Brabazon
A souvenir of Turner's view of Luxembourg
Watercolour and graphite, on grey-green paper
11.4 x 15.6
British Museum

* To make an appointment, call 020 7887 8042.

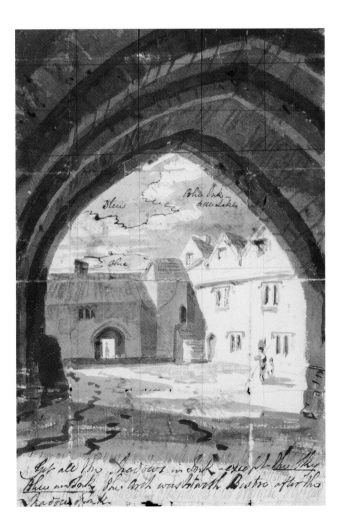

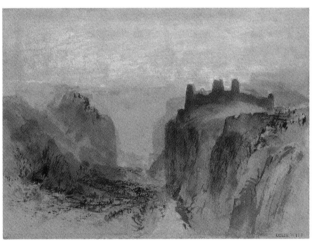

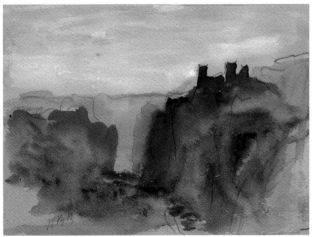

Turner's
Materials

A selection of Turner's sketchbooks, arranged in the sequence Turner devised in the mid-1820s and following the numbers on their spines, beginning with those from his 1819–20 Italian tour. Tate

A Brief History of Watercolour Paints

In medieval times, scribes, manuscript illustrators and map-makers prepared their own colours from ground minerals and water-extracts of plant and animal materials. By Turner's time, watercolour paints could be bought either ready-made or by purchasing and assembling the three basic ingredients: coloured pigments; whitish extenders for diluting the colour of the paint and/or modifying its handling properties; and a suitable paint medium such as gum arabic. These would be spread out together on a glass (or stone) plate with water dripped on top, and then ground by hand to mix them. It was important to disperse and wet the pigment in the medium, and reduce the size of any lumps or coarsely ground pigment particles. Nevertheless, such grinding is easier and faster than it sounds, and certainly much less work than preparing oil paint, a task done by professional colourmen, as is shown in the top image to the right. Five or ten minutes of grinding with a lightweight glass muller (right) in the artist's studio would serve to prepare one watercolour. Earth pigments, such as yellow ochre and burnt umber, are particularly easy and fast to grind. Afterwards the colours could be revived with water and, if kept in a small dish, used without further effort, time after time. The natural descendants of dry pigments ground in gum arabic are the tubes of watercolour used by many artists today, although they were not available in Turner's lifetime.

Turner's large tin paintbox includes bladders of oil-based paint purchased ready for use, as well as many jars of dry pigment, all of them brightly coloured

(opposite). These might have been ground by the artist himself, and used for either oil or watercolour painting. He employed precisely the same range of pigments for both. No Turner muller has survived, though he must have had several. Just like paint brushes, those owned by nineteenth-century artists were not preserved, any more than their painting stools, easels, sketching boards or other studio furniture.

An important factor when making paint is the choice of paint medium. British watercolourists typically use a water-soluble polysaccharide gum medium, of which gum arabic is the best-known example, and the only one that can easily be bought today in artists' shops, ready-dissolved to the right concentration. The main reason for its use is that it permits a thicker layer of paint to sit upon the paper, and dry without flowing out thinly. Another function is to keep the pigment dispersed in the medium. On its own, a heavy pigment like vermilion would quickly settle in pure water, and would have to be stirred before every brush-load was picked up. Although on occasion this might be useful as a special effect, it is not convenient for every brushstroke! Turner's surviving watercolour palettes have been found to contain various gum mixtures that generally include arabic, tragacanth, cherry or sarcocolla, and traces of added sugar. Some, such as the expensive tragacanth and sarcocolla, give a more glossy paint film, whilst others re-dissolve under the next brushstroke more readily than others. Further materials, for example ox gall, dissolved sugar or honey, could also be added to the gum to vary its behaviour. It was the artist's prerogative

J.M.W. Turner
An Artists' Colourman's Workshop
c.1807 (detail)
Oil on wood
62.2 x 91.4
Tate
Detail showing a colourman hand-grinding red pigment on a slab.

Natural ultramarine being ground in gum arabic, with a small muller on a glass plate. The artist would have turned from his painting to do this in the studio.

to choose which properties were desirable, and to control them by adding a mixture of pre-dissolved gums to his hand-ground paint.

An alternative to grinding your own paint was to buy ready-made watercolour blocks. For tinted drawings (see p.26) and maps, specific colours and shades were often used to denote particular subjects, so a good basic range of pre-prepared colours was readily available in little blocks that could be fitted into a paintbox, and replaced individually as they were used up. Today similar-looking blocks can still be bought, and fitted into plastic trays ready for use. In Turner's youth, these were hard watercolour blocks, which were not as easy to use as modern ones. They had to be stirred around thoroughly with a wetted brush every time they were used. Reviving them took about the same time as grinding one's own colours, and the dry pigments were probably cheaper, and always available in tiny quantities in the case of expensive hues. By the end of Turner's life, more user-friendly soft watercolour blocks had been introduced by the artists' colourman Reeves (see p.33). They could be wetted for instant use, and were more convenient for outdoor work. Although they incorporated honey to make them easier to work with, we do not know if the soft blocks had as complete a colour range as the hard ones, or how the costs compared. Turner, in any

case, seems to have preferred hard watercolours, or may simply have been used to working with them. The blocks in his travelling watercolour palettes (see p.33) are hard ones, and since he almost certainly restocked his palettes regularly, these probably date from the end of his life. They have one surprising property: when old and dry they all turn black on the surface, and only scratching reveals the colour range beneath.

Watercolour tube paints today can be purchased as *artists' quality* colours or *students' quality* colours, which are cheaper and less durable. The former will usually consist of the same pigments that Turner used (apart from those which were very poisonous). Student colours are frequently made with synthetic materials which are harder to lift off with water, and often include mixtures of pigments to match the tone of traditional ones. Both types of paint tend to be more fine-grained and therefore less gritty than the historic equivalent. The tube watercolours employed in this book were all of artists' quality. Please note that some of the colours used, although common today, would not have been available to Turner: cadmium red and orange, cobalt blue, titanium white, and permanent mauve or magenta. Scarlet lake, lemon yellow and Hooker's green are made from different mixtures today, but these would look and feel like Turner's paints. JHT

Below:
Turner's metal paintbox. The two bottles of blue pigment at the right, and others in the front of the box, show colours that could have been ground in gum arabic, to use in watercolours.
Tate Archive

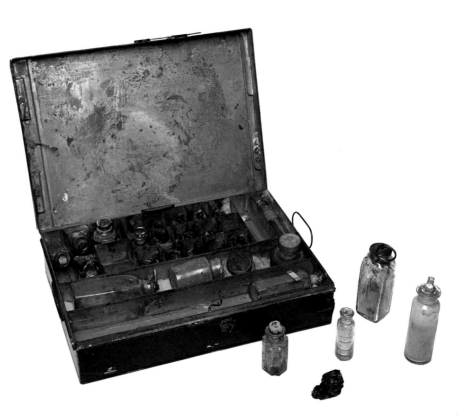

Turner's Use of Colour

Until the end of the eighteenth century, traditional watercolours were known as 'tinted drawings'. They had a limited range of colours that did not replicate those found in nature and the colours were never applied at their maximum intensity. Intense red, blue or yellow primary colours had no place in such works, and nor did full-intensity secondary colours mixed from pairs of primaries. Admittedly the thin washes of the pigments preferred by these early watercolourists were liable to lose colour when exposed to light, so that what we see today is often a faded version of a fairly muted original colour scheme.

Turner led the way in revolutionising the use of colour in watercolour. He inserted small local areas of primary colours into his earliest paintings. In particular, he made frequent use of Mars orange, a very bright orange shade of earth pigment that was manufactured rather than mined, and as a result had a finer particle size and therefore less grittiness than traditional earth pigments. Sometimes he applied it pure and thickly, to give a locally bright orange shade. In other cases, a thin wash of it gave warmth to already applied colours. It may well have been used for both purposes in *Study of Fish* (opposite). In the related study (opposite, top) several

distinct painted-out colours are visible around the edges, and there is a similar number of colours in the image.

Turner first used local areas of warm reds, oranges and yellows in his teenage years, and in later years was equally innovative with spots of bright pure greens and blues. By his middle years he sometimes worked exclusively in non-traditional colour ranges such as red vermilion, chrome yellow and blue ultramarine, all applied in thin washes over whitish paper. When painting colour studies or explorations, he limited himself strictly to the warm/cold contrast provided by two or three of these colours, without the addition of earth colours. However, when he worked on a complex image such as the finished version of *The Blue Rigi, Sunrise* (see pp.8 and 105), he combined both traditional watercolourists' pigments like earth colours, with the full gamut of newly invented ones such as chrome yellow and chrome orange.

In more highly worked images, it becomes almost impossible to ascertain the sequence of colours Turner applied, and to distinguish local colour mixtures from successive paint applications, even when using a good-quality microscope or

a very high-resolution colour reproduction. His skill and spontaneity soon defy the would-be copyist. It is therefore much easier to learn from his unfinished or preparatory watercolours. Painting like Turner can involve 'copying' an unfinished work by the artist, repeating his initial sequence of paint applications several times, then spontaneously taking each version in a different direction, by different means, while still keeping broadly within the overall tonal and warm/cool colour contrasts. This is why Turner often worked on a group of images with similar subjects at the same time, using the same colours, dashing from one to another and back again. He could then develop the best ones, taking advantage of any happy accidents of paint application or tonal contrast. He did sometimes repeat an approximate sequence of steps to make a watercolour, but he was never afraid to break his own rules or try a new effect that might give a stunning and unexpected result. JHT

Left:
J.M.W. Turner
Tail and Head of a Fish; Colour Trials
c.1822–4
Pencil, watercolour and bodycolour on paper
26.7 x 22.2
Tate

Below:
J.M.W. Turner
Study of Fish: Two Tench,
a Trout and a Perch c.1822–4
Pencil, watercolour and bodycolour on paper
27.5 x 47
Tate

These two sheets were formerly one piece
of paper, until cut up by John Ruskin.

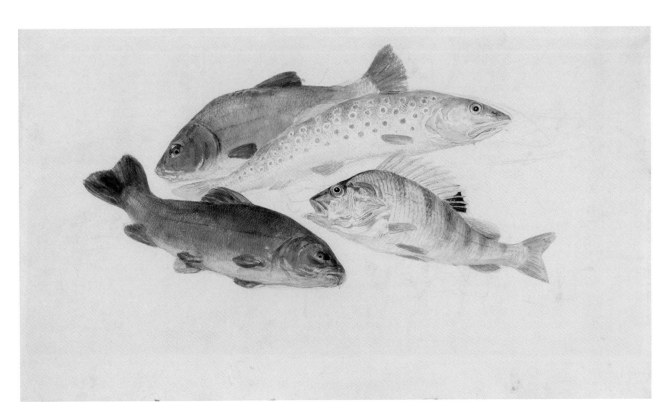

Turner's Yellows

Some of Turner's most daring and experimental innovations centred around his use of yellow. It seems to have been his favourite colour and he used it liberally in both oil and watercolour paintings. By the middle of his career, when industrially manufactured chrome yellows had begun to appear on the market, his affinity began to be noted, and increasingly vilified. For more than thirty years his use of yellow became one of the most frequently mentioned aspects of his art, with critics variously accusing him of suffering from 'yellow fever', 'jaundice on the retina', 'a mania for curry' and 'a strong fit of yellow insanity'. In 1826, his oil painting *Cologne, the Arrival of the Packet Boat, Evening* (The Frick Collection) was described as being 'cut from amber', and in 1830, his picture *Jessica* (Tate) was described as looking like 'a lady getting out of a large mustard pot'. The caricature of the artist by Richard Doyle (1824–83) in 1846 lampooned both his liking for the colour, and his loose and unresolved application of paint.

At the time when Turner began to paint in watercolour, most available yellows were a warm, golden colour, and most of them were opaque. The only way to make a pale transparent yellow was to use a very thin wash of gamboge or Indian yellow, which tended to fade. Turner's early works include more transparent yellow washes, as traditionally used by watercolourists, while later in his career opaque yellow areas are far more common. In adulthood, Turner tried out every new material that

colourmen could offer. Between 1814 and 1815 a whole new range of opaque chrome yellow pigments was manufactured, starting with a mid-toned yellow. By the 1820s, both paler and deeper yellow shades, and a bright orange one, show up in Turner's paintings. The dishes opposite show a range of shades available in modern chrome yellows, typical of those used by the artist. The pale shades in particular met his needs in both watercolour and oil, and he used them in numerous works for the rest of his long life.

All of these colours were intended for oil paints and not watercolours, but an artist like Turner was not likely to be deterred by this fact. He had used bright red vermilion and intensely coloured Mars orange in watercolour, pure and applied at full strength in thick washes, since the 1790s. Vermilion and Mars orange were of course always useful for mixing with every new yellow pigment to produce a redder colour when the need arose. However, once Turner could buy chrome yellow in a range of shades, he generally used little else in watercolour (opposite, bottom), keeping a full range to hand and using far fewer of the other yellows. The only exception was yellow ochre, which harmonised with other earth pigments in paintings of landscapes, rocky shores and other natural scenes. It also mixed well, too, with no settling of the mixture as it dried, and black and yellow ochre mixed together produced a good lime green for spring or sunlit foliage.
JHT and NM

Richard Doyle
Joseph Mallord William Turner 1846
Woodcut
8.5 x 10.5
National Portrait Gallery

Left:
Six shades of modern chrome yellows
and oranges that match the shades
used by Turner.

Below:
J.M.W. Turner
*Dinant from the Roche à Bayard:
Moonlight* 1839
Watercolour, gouache and pen
and ink on paper
13.8 x 18.8
Tate

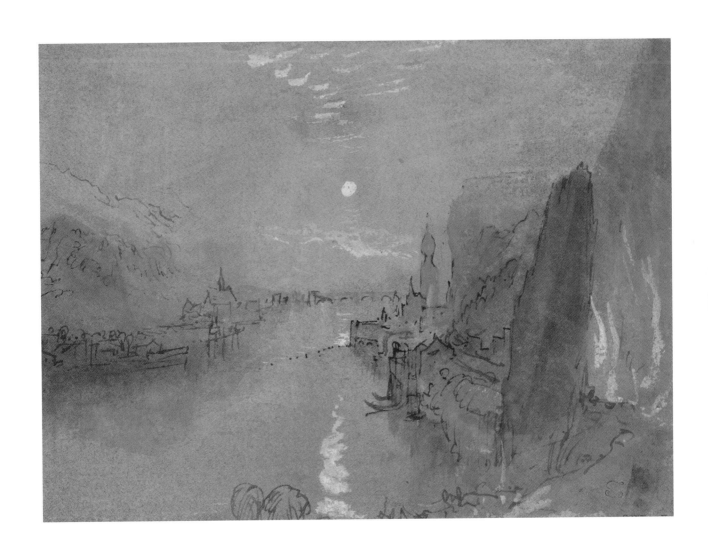

Mixing to Create Tonal Ranges: Green and Purple

When Turner was young, there were no pure opaque green pigments to be had. Instead it was necessary to mix them. Greens for shadowed landscapes could be obtained by combining an earth pigment (such as burnt or raw sienna, raw or burnt umber, or Indian red) and a blue (often indigo), while brighter areas of landscape needed a mixture of yellow ochre or gamboge and indigo. Mixing with Prussian blue instead of indigo gave a more intense, more opaque range of dull green shades.

Another pure colour that was unavailable until after Turner's lifetime was purple. Furthermore, Turner rarely used a thin wash of black pigment, or watered-down ink, to make a grey shade. Instead, greys, slate shades and purplish tones for skies were commonly mixed from indigo and either Indian red or bright red vermilion. Substituting indigo with Prussian blue resulted in darker, more brooding grey skies and intense purplish greys. Brighter purple shades for costumes or flowers could be mixed from these blues or ultramarine combined with madder, which came in shades through rose to deep crimson to rusty red. On occasion, the choice of colour had unforeseen and unfortunate long-term results. Indigo, Prussian blue of the type Turner used, and some of the madder shades, fade quite readily. The loss of indigo or Prussian blue

from a sky mixture often leaves behind startlingly reddish skies, while the loss of madder would leave blue instead of grey clouds.

Most artists who had become proficient in the mixing of greens, greys and purples never adopted newly invented pure greens or purples, in contrast to Turner who used them regularly throughout his life, as each new green became available.

The page opposite demonstrates mixtures of indigo (left column) and Prussian blue (right column). From the top: Indian red, burnt sienna, raw sienna, burnt umber, raw umber and gamboge make greens; and rose madder makes purples. The brighter purple at the bottom left is mixed from ultramarine and rose madder. The grey at the bottom right is lamp black, to give a comparison with a pure grey wash.

Carefully stepped mixtures gave a tonal range that watercolour beginners in Turner's era were encouraged to use in a formulaic manner, usually working from dark shadowed areas up to brightly lit ones. Turner modified this method by working on several watercolours simultaneously, applying the same colour to all of them in turn, then taking up another brush with a new tone, and applying that wherever it was needed across the series of images. JHT

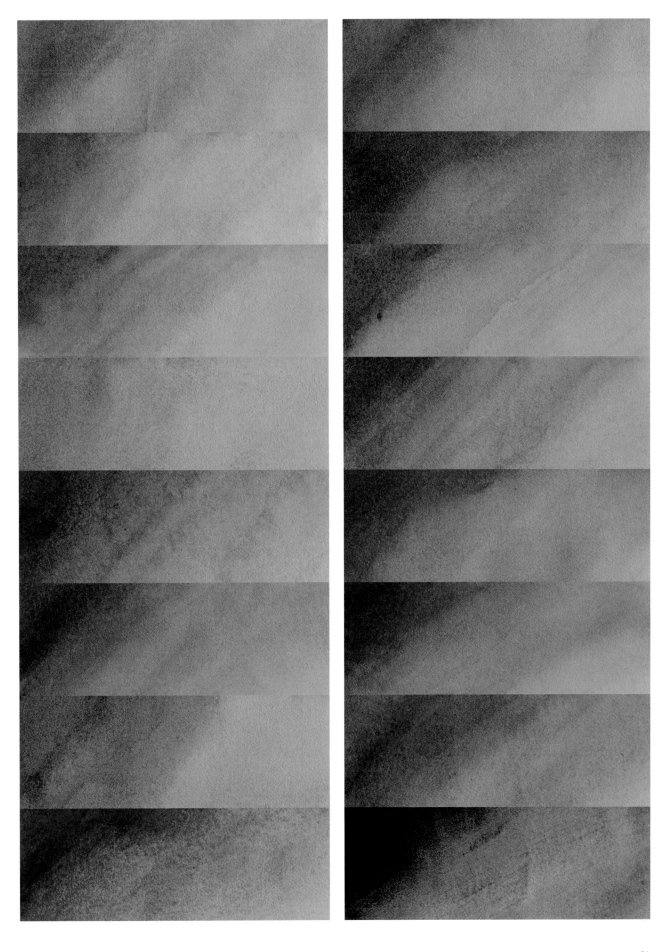

Brushes, Palettes and Drawing Implements

Brushes

Brushes owned by nineteenth-century artists rarely survive. In Turner's case the surviving few have two features in common: short handles and a great deal of wear and broken-off hairs. Both features would have made them convenient for close and detailed work as Turner put the finishing touches to a watercolour. Brushes were always round in profile, with the hairs inserted into a wooden handle and bound round with string. Brush hairs varied in length and springiness, and Turner could almost certainly have bought a wider range of brush types than are available today, and for a more modest outlay. A few minutes' work with a hammer and a pocket-knife would have created an even greater variety of brush shapes. In Turner's day, brushes were very often called 'pencils', especially the small and fine ones traditionally used for watercolour painting.

Palettes

Since Turner worked on white or off-white paper for much of the time, a white palette was a sensible tool to use. Two of his palettes have survived, each about half the size of a contemporary dinner plate, made of thin white china (opposite). On his travels he needed something more portable and less breakable, and he made little pieces of leather into wrap-around travelling palettes onto which he glued a few watercolour blocks, replacing and reglueing them as necessary (opposite, top left). The blocks came from a range of colourmen, whose shops were located during Turner's lifetime in the Covent Garden district of London where he had been born. Colourmen made their watercolour blocks in two-sided moulds, which incorporated the name, address and pigment name on one side, and a rather pleasing logo on the other. Most artists bought from a range of suppliers, probably favouring certain makers for different pigments (see Reeves watercolour blocks opposite).

Drawing implements

During Turner's lifetime, pencils with a neatly shaped wooden gripping surface, as used today, came into common use. He probably drew his earliest sketches with a trimmed sliver of graphite held in a *porte-crayone*, a tweezer-like wooden holder with a locking screw, which gripped the graphite by one end, so that all of the expensive material could be used up for drawing. In the sketchbooks and in the few watercolours in which he drew much detail, he tended to use a soft or blunt graphite pencil for the foreground, and a harder or better-sharpened one for distant areas; thus intensity and fineness of lines both served to indicate perspective.

In some sketches never intended to be coloured Turner used pen and ink, generally making use of the commonest and cheapest ink of his era, iron-gall ink. When freshly applied, this ink is brown, but it darkens to bluish black as it dries. Sometimes he used white chalk, iron-gall ink and graphite pencil, all on brown-washed paper, without any applied colour. One thing Turner did not do was to follow the traditional method of making a tinted drawing: first sketching in pencil, strengthening the lines with ink, and then filling in the outlines with wash. His brushwork was always spontaneous and confident, and even in his early teens there is little evidence that he ever used such a premeditated process. JHT

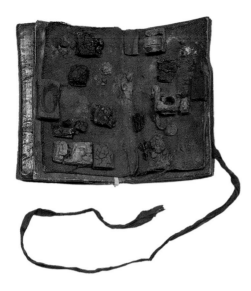

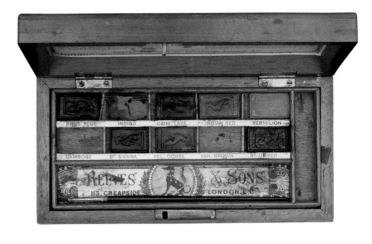

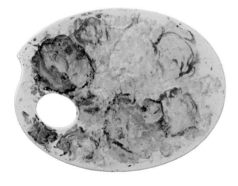

Top left:
Well-used travelling watercolour case, assembled by Turner. He has worn off all the colourmen's logos and labels.
Private collection

Middle left and right, top and bottom:
Reeves watercolour blocks and box dating from the 1860s. The box includes the burnt sienna block shown here in detail with the greyhound that signified the company. The reverse gives the pigment name and maker of the block.
Tate Conservation Archive

Bottom left:
Ceramic watercolour palette used by Turner. It does not appear that he arranged colours systematically or mixed them cautiously to keep them from running together. The messiness accords with descriptions of his rapid, impetuous painting.
Tate, lent by the Ashmolean Museum 1987

Paper

More than with any other type of media, the interplay between watercolour and the support to which it is applied is crucial to the execution and appreciation of the finished image. Turner's own advice was 'First of all respect your paper!', a sentiment that conveys his understanding of the inherent qualities and potentials of different types of paper. It therefore stands to reason that, if one wishes to paint like Turner, one should choose a paper similar to those favoured by him. Ever an experimental artist, his methods often involved repeatedly reworking areas of a sheet, and even changing the surface of the paper so that water and pigment reacted differently in distinct places. Hence he opted to use papers with qualities suited to his technique.

Turner was active during an exciting period in the development of paper and had a wide range of hand-and machine-made materials to choose from, made in both Britain (opposite, bottom) and mainland Europe. For the modern painter, too, there is a bewildering choice available and it can be difficult to know which ones are suitable. Turner undoubtedly used a few simple tests that we can follow to determine some of the intrinsic properties of a sheet and thereby its potential capabilities (further definitions of the words in italics appear on p.138):

1. Take the paper in hand and look through it at a bright light to see the *formation* and fibre distribution. Evenness is key here.

2. Observe its *brilliance* and *texture* by gently bending the paper and seeing how the light plays on the surface; a paper's brilliance will affect how glazes appear within a painting. A rougher texture will weaken flat washes by casting shadows in the hollows in the paper. However, it will also brighten colours worked with a drier brush, as the paint will sit on the high points leaving the natural colour (or previously applied wash) to show through in the depressions (opposite, top).

3. Drag a fingernail along the surface to read a paper's *tooth* (finish texture). The tooth is the amount of friction at the surface and affects how a paper will take up both paint and ink.

4. Now briskly shake the paper to listen to its *rattle*. A higher relative tone for papers of the same weight indicates a higher internal strength. Tearing is also another good way to evaluate this. The internal strength of the sheet dictates how it behaves when wetted and how it can be worked with both brush and other implements.

When selecting a handmade paper look for examples with the highest proportion of linen fibres. The majority of artists' papers today are cotton papers, which are too soft to be reworked repeatedly and do not possess the internal strength of linen papers. Lightweight, smooth papers are also closer to those used by Turner, although the paper should not be glazed.

Most importantly, the paper should be gelatine-sized. Most modern handmade papers are sized with an internal synthetic neutral size, which means that the surface cannot be locally modified. Turner's technique, however, required a mixed surface. He is reported to have vigorously rubbed and worked localised areas within a sheet, removing or weakening sections of the size so that washes were able to bleed or pigment particles become deeply embedded, to give strength of colour. Furthermore, applied colours tend to float on a gelatine surface, making the paint pliable for longer and easier to lift off. Please be aware, however, that gelatine-sized papers must be stretched (or at least wetted and restrained) prior to use, to prevent cockling, or wrinkling (see p.48). If the expense of handmade, gelatine-sized papers cannot be justified, lining paper (available from most DIY shops) is a viable alternative. This paper has been designed to have high internal and surface strengths, and while the texture is too smooth, its coating layer allows for an artist to work with it in the same way as with gelatine-sized paper. It is available in a variety of weights and has a pleasant buff tone reminiscent of wrapping and cartridge papers. It should be noted, however, that it is not a permanent material and will therefore darken and weaken with time and exposure to light.

Ultimately, however, it is up to you, the individual artist, to discover the paper with which you are happiest to work. You should experiment with a range of papers, gaining knowledge and experience of their potential capabilities, eventually developing the expertise to match the paper to the composition, just as Turner did. JT

Left:
A detail of the exercise on p.87 showing
the effect of surface texture on the applied
watercolour. Note how the colour rides on
the high points over the underlying wash.

Below:
Paul Sandby
*A View of Vinters at Boxley, Kent, with
Mr. Whatman's Turkey Paper Mills* 1794
Gouache, bodycolour, watercolour
and pencil on paper laid on canvas
69.3 x 102
Yale Center for British Art, Paul Mellon Fund

Whatman's Turkey Mill produced some
of the papers most often used by Turner
and other watercolourists of the period.

Sketchbooks

Turner filled the pages of around 300 sketchbooks, nearly all of which are in the Tate collection.* It seems that other books were broken up after his death to permit the sale of their most attractive pages, but a further three books exist intact: one of the very earliest filled by Turner is at Princeton University, New Jersey; while both the British Museum in London and the Yale Center for British Art at New Haven, Connecticut, possess sketchbooks used at the very end of his life.

This huge and precious archive, covering the whole of Turner's career, permits us, quite tangibly, to plot his movements, to witness his reactions, and to follow his creative thought processes, almost as if we are peering over his shoulder as he works. In a couple of sketches he even includes an artist studying the landscape, seated on the grass, and this low viewpoint helps to explain the towering perspective Turner himself often adopted. Elsewhere, from page to page, we can observe as he scrutinises and stalks his subject until he finally arrives at the most satisfactory viewpoint.

For the most part, his impressions were noted down in incisive pencil memoranda: he famously claimed that he could make as many as fifteen or sixteen pencil sketches in the time it would take him to complete a watercolour study. Though the books do also contain images in watercolour, considerations of time were evidently of the uppermost concern. As a young man, Turner's attentive eye lent his sketches an exceptional quality that translated the world into linear images

alive with vital detail. However, with time and experience, he found he was able to record less, and to do so in a more summary way, leading to the development of a kind of personal shorthand that is not always immediately comprehensible to the objective eye. Turner must have been aware of the idiosyncratic form of this type of notation and how it might be misunderstood, and was always highly protective of his private visual reference material. Indeed, on one occasion he chased his hostess around a table to retrieve one of his sketchbooks from her before she had time to examine its contents.

The sketchbooks themselves come in all shapes and sizes. Many were bound to order by a stationer (such as William Dickie, who was based on the Strand) from batches of Turner's preferred papers, some of which he had previously prepared with coloured washes. Others he improvised himself as 'homemade' books from bundles of whatever paper was to hand. But he also made frequent use of mass-produced sketchbooks, as well as small commercially available notebooks or almanacs.

Towards the mid-1820s, when Turner's topographical projects sometimes made use of earlier sketches, his ability to locate readily a specific image was possibly hindered by the sheer volume of sketches he had made by then. This was presumably the reason behind his decision to start labelling the spines of his sketchbooks (see pp.22–3). Shortly prior to this, he had been fairly systematic in numbering the sequence of the books he had used on his tour of Italy in 1819–20, and he adopted a similar practice for some of his later travels. IW

Looking down on Rouen from St Catherine's Hill, 1998

J.M.W. Turner
View of Rouen and River from St Catherine's Hill 1821
from *Dieppe, Rouen and Paris* sketchbook
Pencil on paper
11.8 x 12.3
Tate

* See www.tate.org.uk/collection and follow the links from 'JMW Turner' and 'Sketchbooks' for the full range of this material, which is steadily being recatalogued.

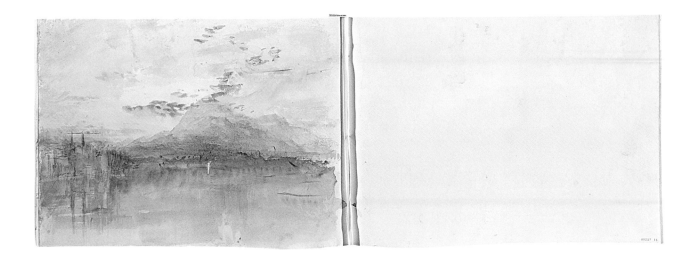

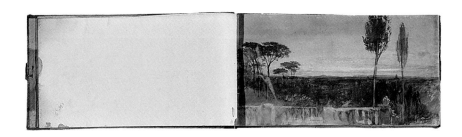

Above:
J.M.W. Turner
*A Man Seated on a Hillside,
Sketching* 1795 (detail)
from *Isle of Wight* sketchbook
Pencil on paper
26.3 x 19.7
Tate

A selection of Turner's sketchbooks,
anti-clockwise from top:
–*The Rigi at Sunrise*, from *Lucerne*
 sketchbook, 1844
–*Rome from the Gardens of the Villa Mellini,
 Monte Mario*, from *Small Roman Colour
 Studies* sketchbook, 1819
–*Ehrenbreitstein and the Mosel Waterfront
 at Coblenz*, from *Rhine* sketchbook, 1817
–Turner's inscription on the cover of *River
 and Margate* sketchbook, c.1806–8
–*Study of the Back of a Reclining
 Female Nude*, from *Academies*
 sketchbook, c.1804

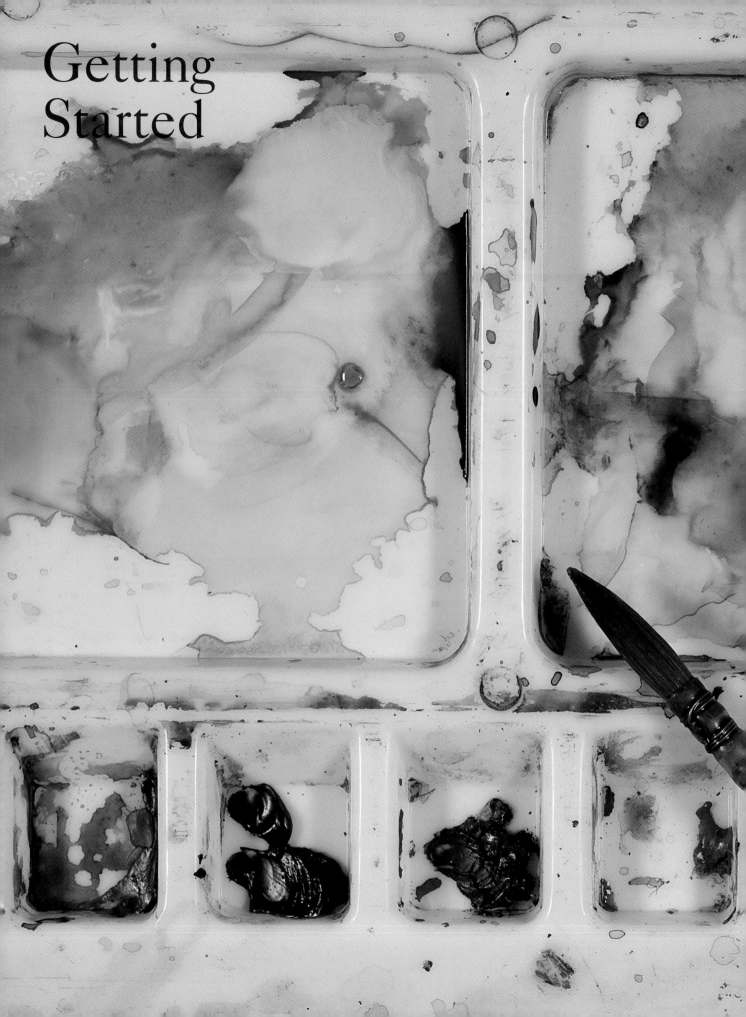

Getting
Started

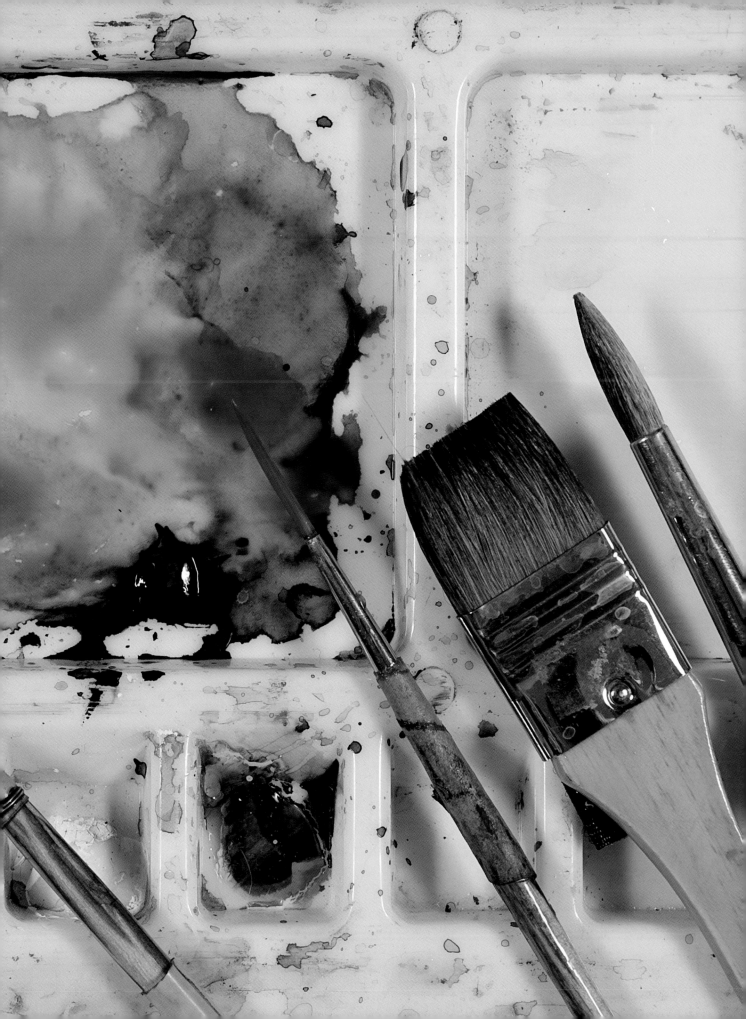

Modern Materials You Will Need

Mike Chaplin

You may already have some art equipment or you may be entirely new
to painting. The advice on what you will need is based on the very simple
materials that were used for the step-by-step paintings within this book.
Our suggestions can serve as a guide but it's important to remember these
exercises are about experimenting and finding out what works well for
you. You might already have alternatives, or you might take these basic
suggestions and add to them.

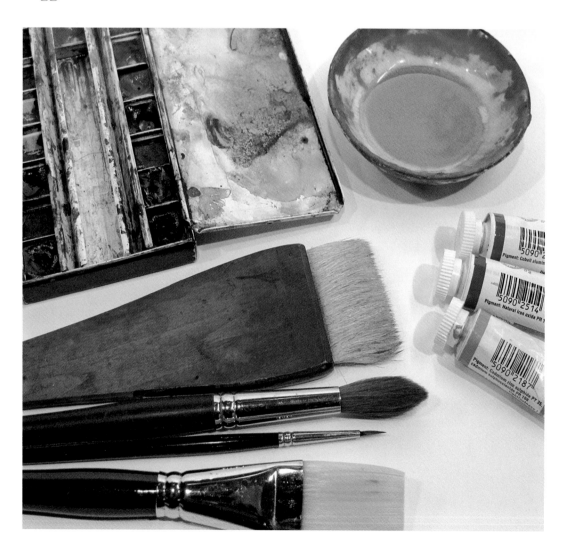

Paint

The colours specified within the exercises are predominantly *artists' quality* (as opposed to *students' quality*) watercolour from tubes. You may also find it useful to purchase a basic set of 'pan' colours in a box. You can use these to modify our suggested colour and to experiment in order to get a truly Turneresque look! In every case, the materials suggested in this book are not (very) poisonous. Nonetheless, we recommend that you separate your painting activities from all eating and drinking (even bottled water) and that you wash all paint off your hands afterwards.

The following are a good basic range of colours:

Blues:
Cobalt blue
Ultramarine
Cerulean blue
Prussian blue

Reds:
Cadmium red
Scarlet lake
Indian red

Yellows:
Lemon yellow
Chrome yellow
Yellow ochre
Cadmium
 yellow deep

Browns and Oranges:
Raw umber
Burnt umber
Cadmium orange
Burnt sienna

Others:
Ivory black
Titanium white
Neutral grey
 gouache
Hooker's green
Winsor violet
Permanent mauve
Permanent
 magenta

Brushes

Most watercolour painters make use of a range of brushes. They can be very expensive but it is worth investing in at least one or two good-quality sable brushes. However, many of Tony Smibert's quick exercises can be painted with a single, inexpensive, imitation sable brush. Remember that your brush is the point of contact between you, your ideas and the paper.

The following were used for the exercises within this book:
– Flat nylon wash brush
– Flat sable wash brush
– Large pointed sable brushes, nos.6–10 depending on the scale you're working to (referred to as 'round' brushes, these can be used for washes and painting in large areas, and, if you have a good-quality brush, you should be able to use the tip of the brush for fine details)
– Fine sable brushes, nos.2–4, depending on the scale you're working to (referred to as 'rigger' brushes, these are long-haired and ideal for fine drawing and long lines)
– A large imitation pointed sable brush, around no.10 (a cheaper brush than the above that will allow you to be a bit rougher and experiment to make interesting marks)
– A short hog hair bristle brush (e.g. a stipple brush)

Paper

Finding suitable paper can be difficult as modern papers differ significantly from those that were generally available to Turner. They tend to greater whiteness than nineteenth-century materials, and specialist tinted and textured handmade sheets are expensive. Gelatine-sized papers are also hard to find.

Try experimenting and expect to see some differences in result from Turner's examples. A simple alternative to some of the coloured papers is to try pastel paper, which gives a similar 'feel'. You can also colour your own heavyweight papers by brushing or dipping the sheet with a watercolour wash (see p.101).

For further advice on paper see pp.34–5.

Other bits and pieces

You will also find it useful to have:
– Gum arabic (a small bottle)
– Soft pencil (2B or 4B)
– Charcoal pencil
– Sharp blade (for scratching out paint)
– White palette or plate for mixing
– Water pots (1 for clean water, 1 for mixing paint, 1 for washing brushes)
– Tissues, a damp cloth or other absorbent material for removing paint
– Blunt tool, e.g. quill of a feather or a drinking straw

Introduction to Watercolour

Tony Smibert

The foundation of Turner's genius was a thorough understanding of the properties of watercolour. If you are new to watercolour painting, this chapter provides a brief introduction to some of the traditional basic techniques. It is not intended to provide a complete course in how to paint, but instead is aimed at giving you an insight into ways of using the medium as Turner did.

Below:
J.M.W. Turner
Inscriptions and colour trials by Turner
from *Matlock* sketchbook 1794
Pencil on paper
11.3 x 18.5
Tate

Flat wash

This simple but useful technique involves covering the paper with a single 'flat' layer of colour. Turner frequently used a flat wash to cover white sheets of paper with a background tint.

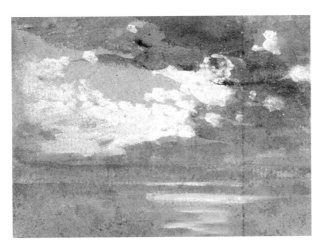

J.M.W. Turner, *Study of Clouds over Water by Moonlight* 1796 (detail), from *Studies near Brighton* sketchbook
Watercolour and gouache on blue paper, 11 x 12.9, Tate
This sketchbook page contains flat washes to describe the smooth expanse of sea.

1. Load a large, flat brush with watercolour and then, with the tip downwards (so that the wash will naturally flow from it) pass it sideways across the paper creating a relatively even band of colour. Try angling your painting surface so that the watercolour will naturally pool at the bottom of the stroke.

2. Reload the brush and pass it back and forth across the page in successive stages until the sheet is fully covered. Each stroke should touch the lower edge of the previous band of colour and pick up the paint that has pooled there. Keep the washes fluid and continuous and you will achieve a smooth and even surface.

3. When you have reached the bottom, remove any excess paint. One way is to pinch out the remaining wash from your brush using your thumb and forefinger, then use the 'thirsty' brush to sponge up the pigment. Alternatively just wipe around the edges with tissue or a damp cloth. At this point you can leave your wash to dry (or cheat by using a hairdryer to speed up the drying process).

Variegated wash

One of the most beautiful visual effects achievable with watercolour is the variegated wash. This combines loose wet washes of different hues, resulting in a change of colour across the same painted area. Turner often used bands of variegated washes within paintings of the sky.

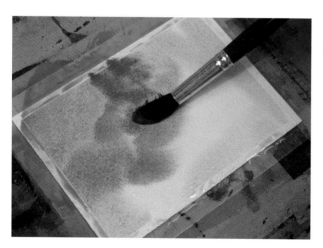

J.M.W. Turner, *A Stormy Sunset* c.1822
Watercolour on paper, 17.1 x 24.5, Tate

1. Freely apply a liquid wash of colour to a wet sheet of paper.

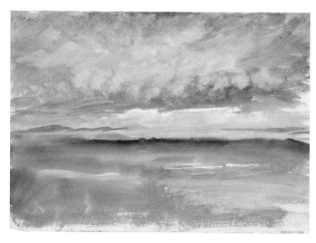

2. Work with successive wet washes, applying each new colour where the last brushstroke finished so that the colours run together. It doesn't matter how many colours you use, or in what order: the process is the same.

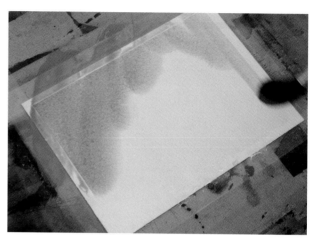

3. Alternatively, wet your sheet on both sides and smooth it onto a board before making successive strokes of colour. You can use this to create wonderful effects.

Other ways of adding paint

Mingling
Mingling involves placing different washes alongside one another so that they naturally blend at the meeting point.

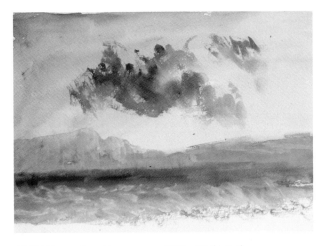

J.M.W. Turner, *Two Seascapes* c.1820–30 (detail)
Watercolour on paper, 43.1 x 30.5, Tate
Here, Turner has used an area of mingled blue and mauve paint to describe perfectly a menacing dark rain cloud.

Gradated wash
Also known as 'graduated' or 'graded' wash, this uses the same processes as a flat wash. When working onto dry paper, the brush is dipped into clean water after each pass so that a gradual change in tone occurs. Alternatively, when working onto wet paper (see Stretching your paper, p.48), simply allow the colour to flow out of the brush while making successive rapid passes so that the wash fades tonally from dark to light.

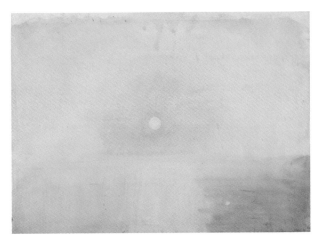

J.M.W. Turner, *Sunrise* c.1825–30
Watercolour on paper, 33.4 x 47.2, Tate
The subtle changing light of this dawn sky was created by Turner with a gradated yellow wash, radiating outwards from the sun in the centre.

Wet-in-wet

Wet-in-wet is probably the most characteristic technique in Turner's repertory and one of his most innovative contributions to the art of watercolour. It involves the application of colour using a wet brush on a wet surface, so that the paint softens and blurs.

J.M.W. Turner, *Boats at Sea* after c.1830
Watercolour on paper, 22.2 x 28, Tate
Here Turner has painted two simple forms using wet-in-wet that suggest distant boats reflected on a flat sea.

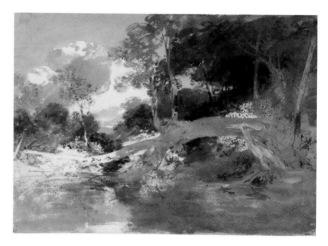

Dry brush

Making marks with a wet brush onto dry paper leaves crisp-edged marks, as this close-up shows, and is called dry brush. To fully understand the difference between wet-in-wet and dry brush, try wetting one half of a sheet of paper, loading a brush with colour, and making a few passes right across the whole sheet.

J.M.W. Turner, *Fonthill: A Fallen Tree Beside a Lake* 1799
from *Fonthill* sketchbook
Pencil and watercolour on paper, 33.5 x 43.3, Tate
In this early landscape, Turner drew the foliage of the trees using the dry-brush technique.

Charging
Introducing wet colour into the middle of a wet area of another colour is known as charging.

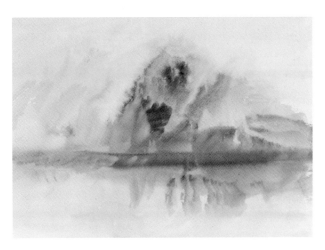

J.M.W. Turner, *A Lurid Sunset* c.1840–5 (detail)
Watercolour on paper, 22.5 x 28.2, Tate
In this detail Turner has diffused a stain of red within a warm orange to describe the fiery glow of the setting sun.

Spatter effects
A wide range of experimental effects can be achieved by randomly flicking or spattering colour onto the paper. A bristle brush works well for this.

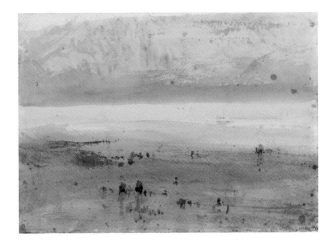

J.M.W. Turner, *On the Sea Shore* c.1830–5
Watercolour and gouache on paper, 19.2 x 27.3, Tate
Turner spattered paint in the foreground of this seascape to create a grainy textured effect for an area of wet, sandy shore.

Artist's Techniques

Creating White

Reserved White: Perhaps the simplest way to create a highlight is to leave an area of paper untouched by paint. This is called a 'reserved white'.

Stopping Out: When one part of a painting surface is protected from further paint by water-resistant masking this is called stopping-out. In the past, gum arabic, wax and other materials were used. Today commercial masking fluids are available (see p.103).

Wet Removal: Depending on whether it has stained right into the fibres of the paper or merely dried on the surface, there are many ways to remove watercolour. Wet paint can be lifted using a damp brush, a dry tissue or blotting paper. It can be swept from the paper while still wet in order to lighten the tone of a wash, or drained away by angling the painting board. In controlled sections it can be washed away by placing the paper under a tap, by sponging or by spraying with a bottle-sprayer. Smaller areas can be scraped to one side with a blade.

Dry Removal: Dried paint can be scraped or scratched away with a blade (or even a long, sharpened thumbnail, in Turner's case) to reveal the paper below. It can also be teased or flicked with a bristle brush and then dabbed to create the play of light. Furthermore, dried wash can be wetted overall or within very carefully defined areas. It can then be lifted with varying degrees of success (depending on the paint and paper types and the painter's skill) to create marvellous effects. The applications are many and the possibilities endless.

Stretching your paper

Depending on what type of paper you are using you may need to stretch it before starting to paint, so that it does not cockle or warp. This traditionally involves saturating a sheet with water and taping it down so that it dries flat. However, an easy solution that Turner may have used on occasions is to thoroughly wet your painting board or table, as well as both sides of the paper. Lay the paper onto the wet surface and smooth it out. It is now ready to use. Even lightweight papers will stay in position and be quite strong to work on with this treatment. Once you have achieved the desired result, the wet sheet can be gently peeled from the board and laid out to dry on a flat surface.

Mark-making

Close examination of Turner's watercolours reveals an astonishing array of marks made using different-sized brushes, and even at times his fingers (see *Goldau* detail right). Small or large, wet or dry, brushes are capable of making a huge variety of strokes. A classic sable 'round' brush will make a wonderful range, and even brushes not intended for watercolour can be coaxed into creating unusual effects simply by dotting, dabbing, dragging and even rolling the brush.

J.M.W. Turner
Goldau, with the Lake of Zug in the Distance: Sample Study c.1842–3 (detail)
Pencil, watercolour and pen on paper
22.8 x 29
Tate

Brushmarks

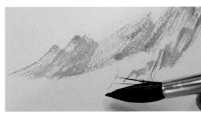

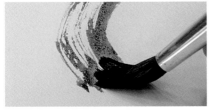

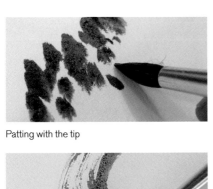

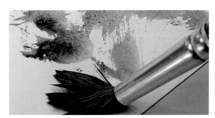

Patting with the tip

Rolled while pushing

A nearly dry, splayed brush dragged sideways

A wet brush swept down

A wet brush dragged sideways

Pressed down with the hairs spread

With the tip splayed: dabbing

A very dry brush swept sideways

A nearly dry, splayed brush

With the tip splayed: pushing

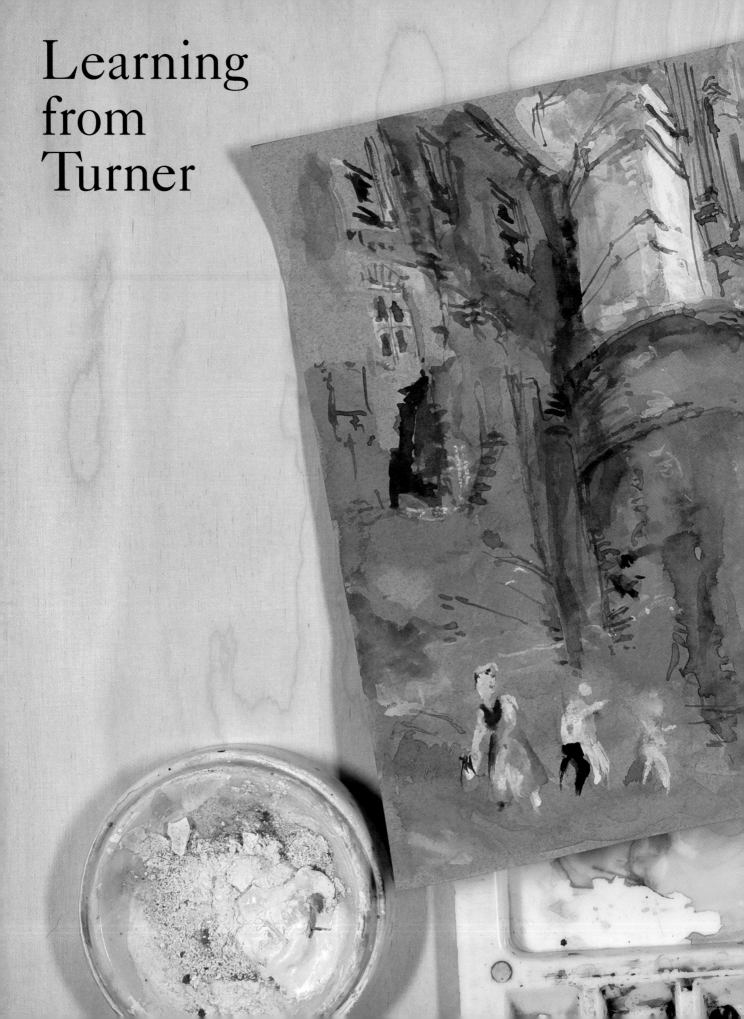

Learning
from
Turner

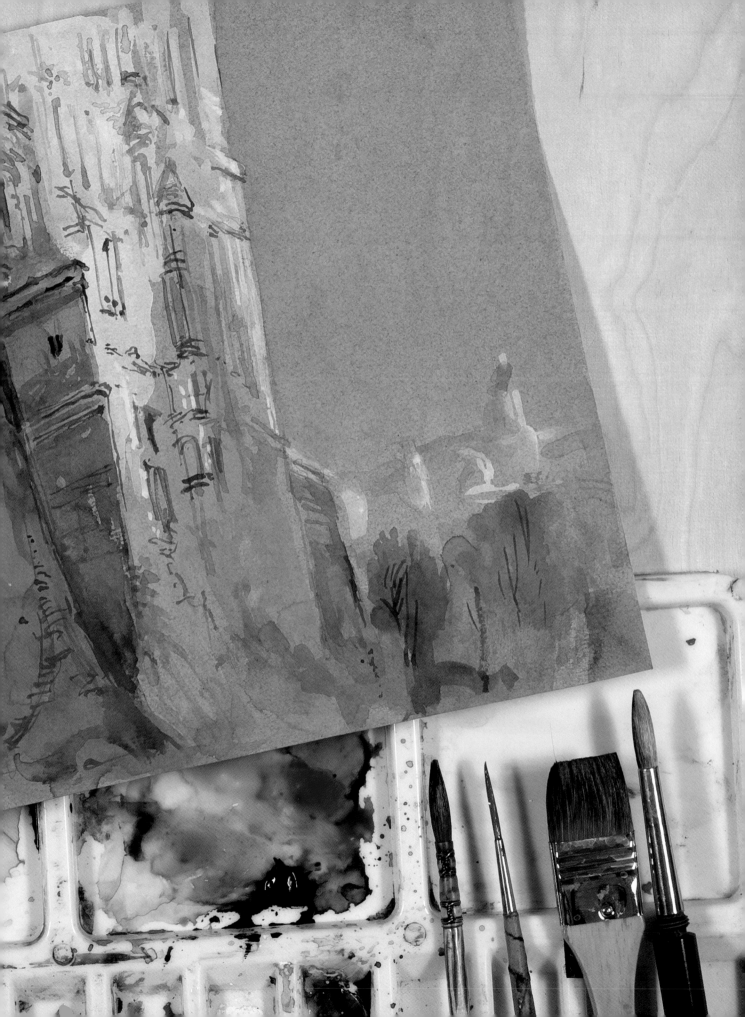

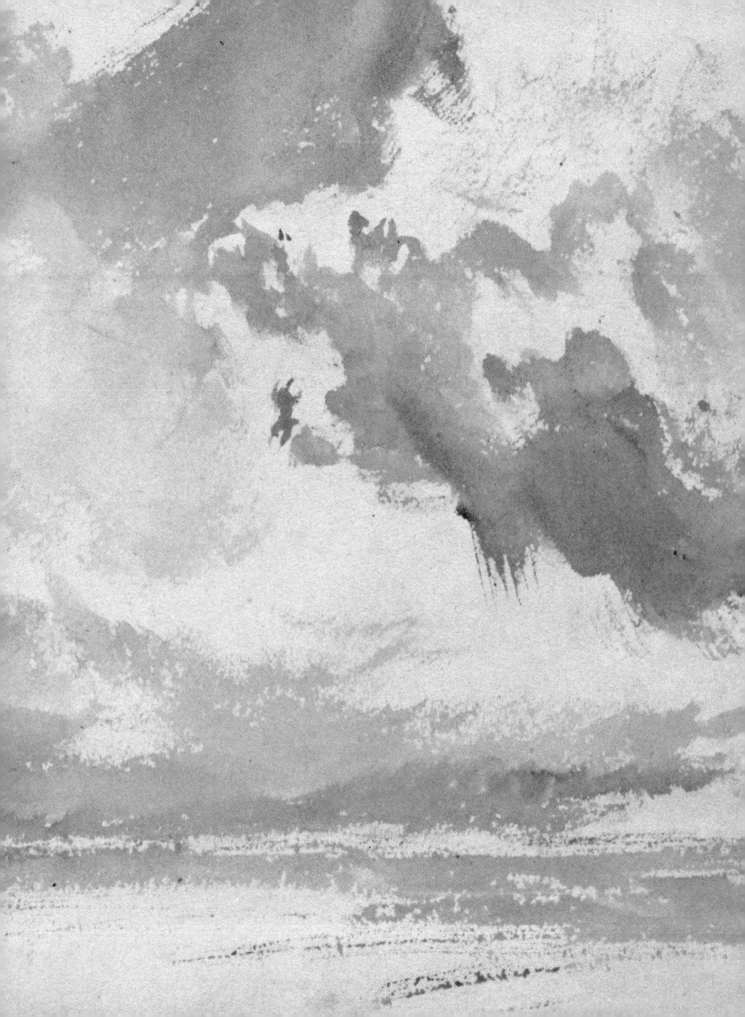

Sky

One of the things that preoccupied Turner throughout his life was the study of natural phenomena and how to render them visually. As a young boy he would spend hours lying on his back, absorbed in contemplating the changing effects of clouds, sun, wind and rain. In later life his obsession repeatedly took him to Margate, where the long coastline provided an uninterrupted view of the vast expanse of sky. He would sit at the window of his landlady's house looking out towards the sea, and paint the constantly changing skies that he purportedly believed to be 'the loveliest' in Europe.

Left and below:
J.M.W. Turner
Study of Sky c.1816–18 (detail)
and *Study of Sky* c.1816–18
from *Skies* sketchbook
Watercolour on paper
12.5 x 24.7
Tate

Although Turner pursued the problem of how to render naturalistic effects in oil, the inherent characteristics of watercolour in particular made it an eminently suitable tool for capturing and expressing something as nebulous as weather. The translucent washes of watercolour enable light to pass through and reflect from the paper beneath. Turner derived new ways of applying the pigment to the support, which hugely increased the range of watercolour. He perfected the technique of 'wet-in-wet' to produce the effect of subtly evolving changes in atmosphere (see p.46). Bold swathes of colour applied on a wet background would naturally and seamlessly integrate, mirroring the unconfined transience of light itself. When experimenting with cloud forms he exploited the medium's exciting element of chance by dropping touches of colour into a damp wash, allowing the paint to diffuse and merge and creating soft and effective shapes. His infatuation with observing the sky was such that he devoted an entire sketchbook to it. From serene dawn to moody twilight, and passing squalls to gathering storms, the *Skies* sketchbook contains page after page of the depiction of changing weather, a visual essay in the perpetual flux of the heavens.

Some of Turner's most lyrical skies are to be found within a group of informal and preparatory watercolour studies known as 'colour beginnings'. Sometimes these works map out the tonal components of a planned picture, and sometimes they are simply exercises in composition, colour and the expressive possibilities of paint. As a general rule the flat line of the horizon bisects the picture plane, imposing a natural structure. The simplicity of this motif

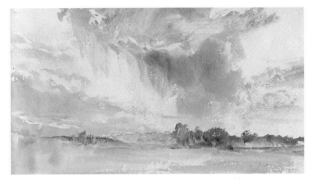

provides an ideal vehicle through which to experiment with the elaborate rhythms of the changing elements. Although at first sight they might appear to be evidence of the abstract reduction of landscape to a simplified formal arrangement of colour, the notion of these watercolours as finished works of art is not an idea that Turner himself would have understood or endorsed. Unseen during the artist's lifetime, they were intended for private reference, a necessary component of the artist's working process, rather than individual images in their own right. Nevertheless, they have much to teach the modern watercolourist about technique and the depiction of naturalistic effects. The inspiration for this chapter comes from these colour beginnings, in which the principal focus is the movement and dynamism of clouds. NM

How to Paint
Storm Clouds, Looking Out to Sea

Mike Chaplin

The revelation when painting this study after Turner was the discovery that he used his fingers rather than a brush to produce the curving forms in the sky. A bold approach is needed. Work swiftly with lots of water and liquid paint, and don't be afraid to get your hands dirty!

Colours used in this exercise:

Lemon yellow

Burnt umber

Indigo

Cobalt blue

Permanent mauve

Below:
J.M.W. Turner
Storm Clouds, Looking Out to Sea 1845
from *Ambleteuse and Wimereux*
sketchbook
Watercolour on paper
23.8 x 33.6
Tate

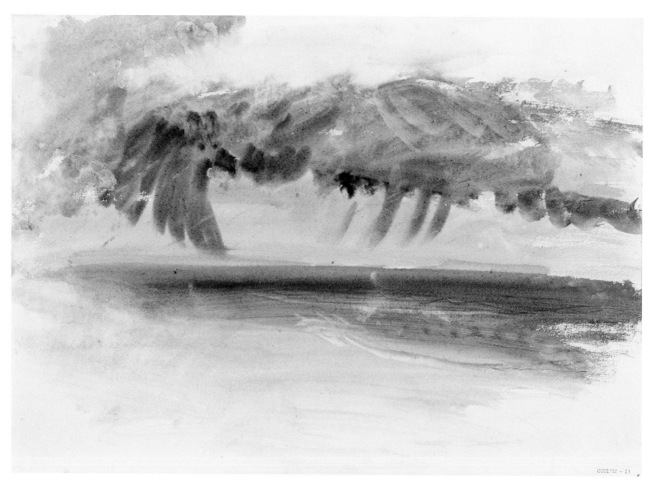

1. First wet a pre-stretched watercolour block or sheet of paper. Using a flat sable wash brush, mix fast and loose washes of lemon yellow and burnt umber directly onto the water-soaked paper.

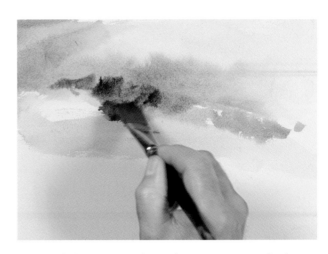

2. Add a dark accent into the wash, using a mixture of indigo and burnt umber with plenty of water. Use a little cobalt blue to assist the granulation.

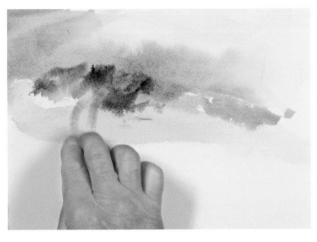

3. With wet fingers, pull the wash down to form the veils of rain falling from the clouds. Enough paint needs to be laid to complete all the marks.

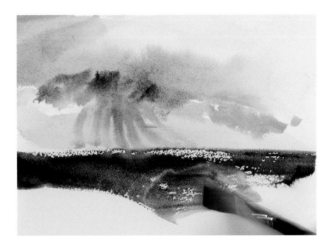

4. Fully load a wash brush with indigo and sweep it across the paper to paint the sea. In this example, a combination of speed and strong surface sizing has left white 'sparkles' within the pigment.

exercise continues overleaf

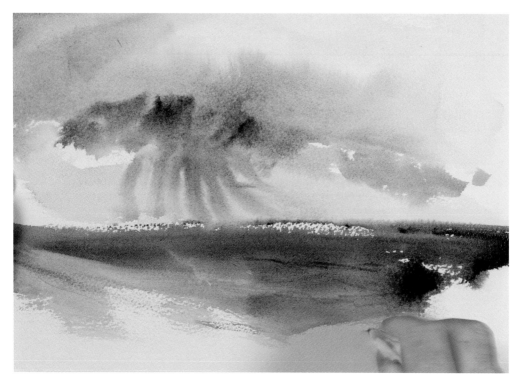

5. You can create subtle detail within the sea by scratching the paper with a fingernail. Paint enters the damaged surface and creates fine dark lines. You can also lift paint off wherever necessary using a tissue, as shown here.

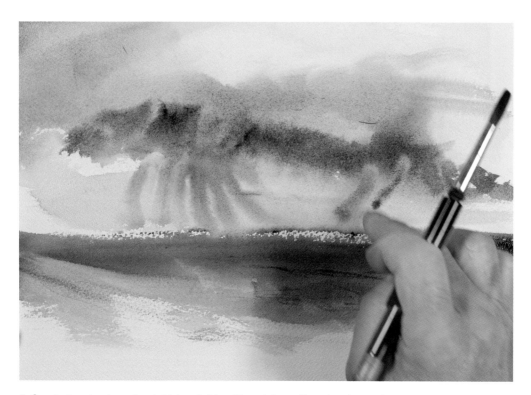

6. Create the clouds on the right-hand side with a mixture of burnt umber and permanent mauve (or Winsor violet) and, as before, pull them down using a finger.

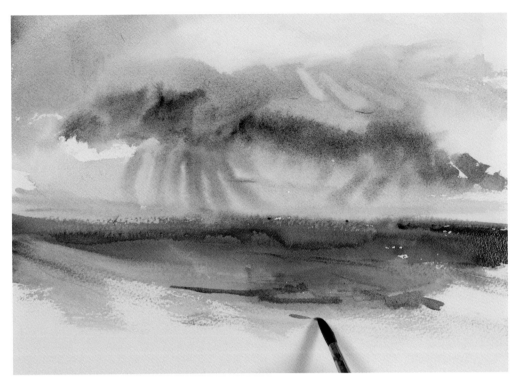

7. Remove light areas from the right-hand clouds using a tissue. Use a large pointed sable brush to introduce the suggestion of foreground waves using indigo with a little cobalt blue.

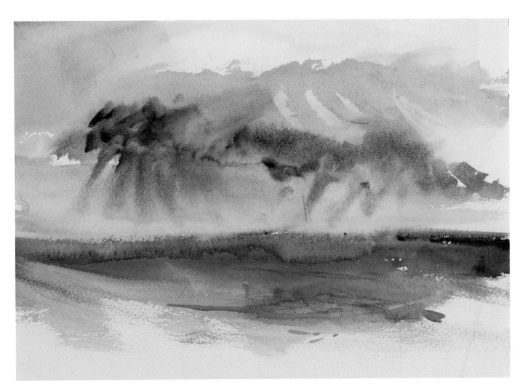

8. The naturalistic immediacy of the moment has been captured by painting at great speed in a continuous sequence.

Painting Sky 1

Tony Smibert

Using clouds as composition

Turner's cloud studies are powerful in their simplicity. He knew how to use colour harmonies and dynamic brushwork to create incredible effects. Put the issue of colour aside for a moment, and consider how much this study depends upon the dynamic use of brushwork to capture not only the character of the clouds Turner is painting, but also their relationship to the sea below. The following simple examples illustrate how you might use cloud shapes as Turner did, to create or enhance the drama in your own compositions.

Below:
J.M.W. Turner
Study of Clouds c.1823–4
from *Old London Bridge* sketchbook
Watercolour on paper
10.3 x 16.7
Tate

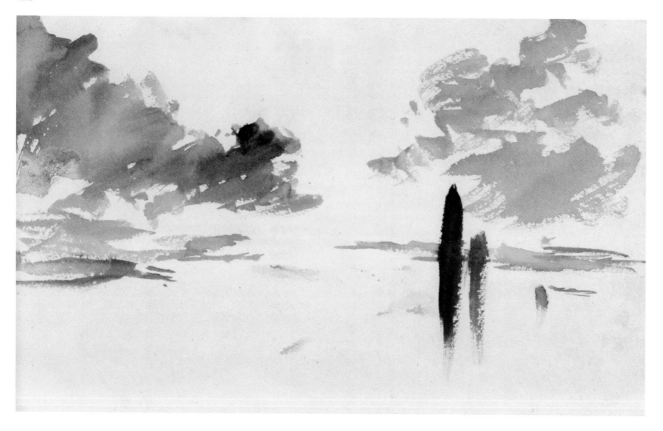

1. Load a large sable or imitation sable brush with any grey and use your sketchbook to make rapid, gestural drawings. Try to capture the feeling that you are building real clouds and let them fly across the page as if tossed by the wind.

2. Immediately suggest the land or sea below, and connect this to the sky by dragging some of the colour from the cloud down towards the horizon – rain squalls perhaps.

3. You can make quite a few studies on a single page, experimenting with different forms. Try sweeping the brush sideways to form dramatic cloud shapes. These can be an important element in composition, both for dry-brush sketches or when sketching wet-in-wet.

4. Practise using a nearly dry brush (test it on a scrap of paper first) to sweep a descending curve of cloud across an imaginary sky. Beneath this, a single pass of the brush-tip establishes the distant horizon while, beneath the cloud, the ocean seems to come towards us. Try to see the clouds as part of a sky and a composition rather than merely as clouds.

Painting Sky 2

Tony Smibert

Using colour for clouds

The key to painting skies is to study them first hand as Turner did. Take your watercolours out of doors and sketch the changing moods of nature as seen in the skies before you. Allow your brush to fly across the page, responding to your observations without hesitation (the sky changes constantly) and to connect the sky to the landscape below it.

Try to visualise your own view while experimenting with Turner's techniques. The following exercise was based upon a Turner method for depicting clouds in rapid colour studies. Do not worry about duplicating a particular watercolour; simply note and apply his approach. Studying his works in this manner should empower you to paint the world around you in your own way.

Below:
J.M.W. Turner
The Storm Clouds c.1820–30
Watercolour on paper
30.5 x 50.5
Tate

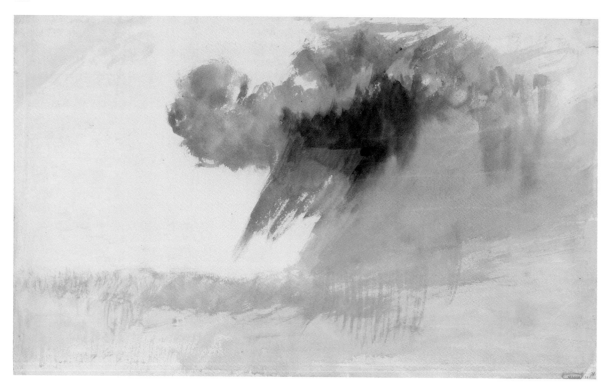

1. Block in the warm light of an evening sky using a flat, gradated or variegated wash. This simplest of washes is comprised of one colour, yellow ochre.

2. While the paint is still wet, load your brush with a warm, neutral grey and quickly form the soft shapes of distant storm clouds. Use a paler wash to suggest distant clouds in the upper corner and to drag out some rain showers driving down towards the land or sea below.

3. Use the same pale wash to suggest the sea below with some darker crests.

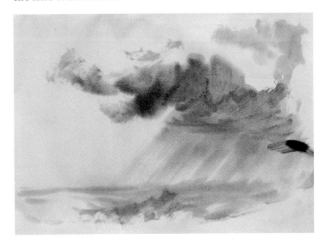

4. If you flatten the bottom of the clouds by using horizontal strokes it will suggest that they are receding away from the viewer. Turner used this approach as a way of dashing down impressions of fleeting effects, so try to take no more than a few minutes for the entire sketch.

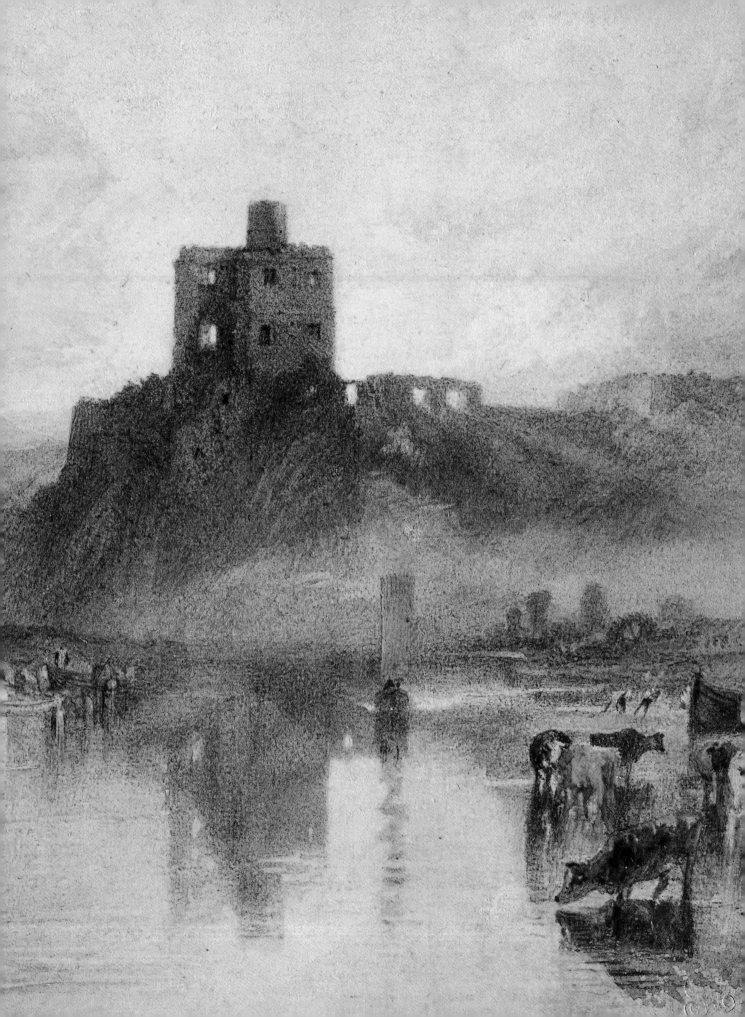

Water

Even though Turner is always referred to as a great landscape painter, much of his output was actually concerned with being on or near water. This preoccupation is partly a condition of British cultural identity and of living on an island surrounded by the sea. But it also reflects a childhood spent in central London, close to the banks of the Thames, where the water trade on the river would have formed endless images to store up in his mind's eye.

Left:
J.M.W. Turner
Norham Castle, on the River Tweed
c.1822–3 (detail)
Watercolour on paper
15.6 x 21.6
Tate

Below:
J.M.W. Turner
Study of a Breaking Wave 1801
from *Dunbar* sketchbook
Pencil on paper
11.5 x 16.2
Tate

Turner lived in an age in which his travels invariably followed the course of rivers, or took him repeatedly across the Channel. He watched the progress of barges, laden with produce, as they were towed upstream, or along Britain's network of canals. And although he stood in awe of the great masted machines of war that subdued Napoleon's fleet, he also celebrated the new steamboats that started to add their dirty plumes of smoke to the skyline from the 1820s. Indeed, one of the incidental pleasures of his sketchbooks and watercolours is that they provide a catalogue of the diverse craft, adapted to local circumstances, that could be found plying the waters between northern Scotland and the Gulf of Naples, and scores of places in between.

But Turner's marine and riverside images are not distinctive solely for their depiction of the antics of the fishermen, sailors and pleasure-seekers. What most struck his contemporaries as remarkable was his ability to recreate a sense of the motion and the surface qualities of water, even if on occasion some viewers of his oil paintings found the very physical traces of the sweep of Turner's brush and palette knife too bold in their approximation of the undulating, frothy waves of a storm.

Turner's observations of the sea are all the more impressive in having taken place in advance of the development of photographic techniques, which permitted the eye to study waves temporarily frozen at the top of their arc, held in suspense before the weight of water continued to crash downwards. In a sketchbook used on the Scottish coast, near Dunbar (right), and on many other occasions throughout his travels, Turner made notes that anticipate the photographic studies of waves by Gustave Le Gray from the mid-1850s.

As well as the drama of churning seas, Turner excelled at creating reflective expanses of still water. His rare moments of relaxation were often spent fishing, and he presumably spent countless hours looking out over tranquil water, carefully absorbing the way light played over its surface, all the time waiting for the fish to bite. In his watercolours, he understood that the most successful means of suggesting the dazzle of reflected sunlight depended on the brilliance of his paper, which he left unpainted, defining this as the most intense light by gradating the areas away from it. It was an effect he had particularly admired in the celebrated watercolour *The White House at Chelsea* 1800 (Tate) by his friend Thomas Girtin, which he reproduced in many of his breathtakingly economic depictions of Venice, in which the city is no more than a mirage, buoyed up in a haze of sparkling light. IW

How to Paint
Venice: San Giorgio Maggiore – Early Morning

Mike Chaplin

This is a deceptively simple painting, full of light. It is important that the tonal recession is finely balanced to achieve this sense of space. Remember that washes dry lighter than when first laid, so it will pay dividends to do a few tests on a sheet of the same paper that you are going to use for your final painting.

Colours used in this exercise:

- Ultramarine
- Lemon yellow
- Cadmium orange
- Burnt sienna
- Cerulean blue
- Ivory black

Below:
J.M.W. Turner
Venice: San Giorgio Maggiore –
Early Morning 1819
from *Como and Venice* sketchbook
Watercolour on paper
22.3 x 28.7
Tate

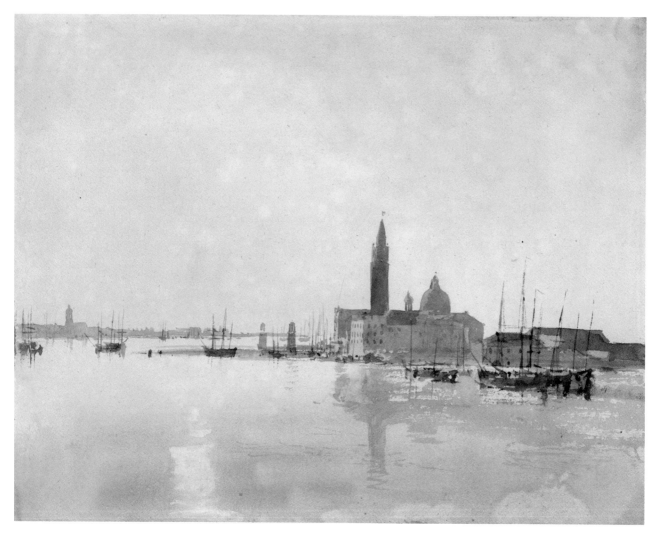

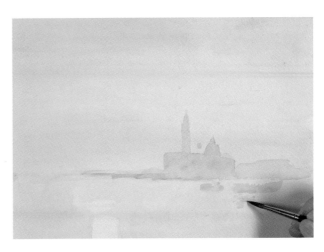

1. Lay in the basic tonal areas by applying thin washes using a large, flat brush, gradating from a pale ultramarine at the top, through lemon yellow to orange, and returning to blue at the bottom. Thinking ahead to where you want to create the dazzle of sunlight on the water, leave two small areas of paper untouched at the bottom.

2. Faintly sketch in the outline of the church and campanile of San Giorgio, and then colour these areas with the first wash of burnt sienna using a large pointed sable brush.

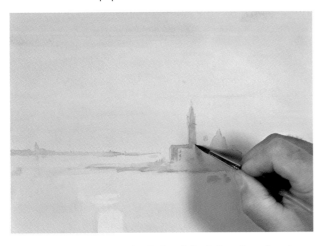

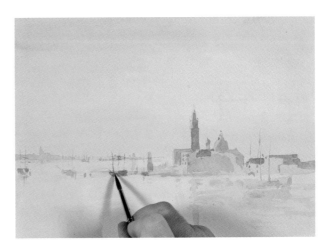

3. Use cerulean blue to indicate the distant shoreline of eastern Venice and the Lido; you can also define the glancing light on the left face of the campanile with this colour.

4. Continue to build up and strengthen features, like the frames of windows, or the hulks of the ships, with localised touches of your brush. Use the ivory black here to darken the other colours in your palette.

exercise continues overleaf

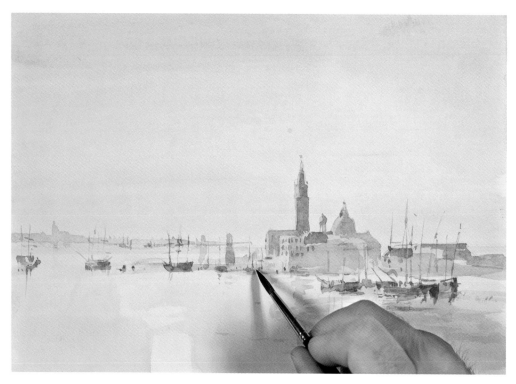

5. For some of the very finest details, such as the masts of the ships, you will find it necessary to flick these in quickly using a fine sable. You can stick with your large pointed sable if it's good enough quality to produce a fine line; otherwise use a finer brush such as a no.2 or 4.

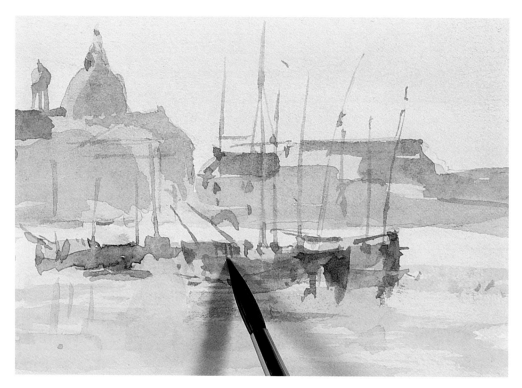

6. Now that the image is almost resolved, you can add warm accents to the foreground ships using burnt sienna, contrasting them with the dark tones of the cool shadows. This pushes back the middle distance and helps to establish a real sense of depth and airiness.

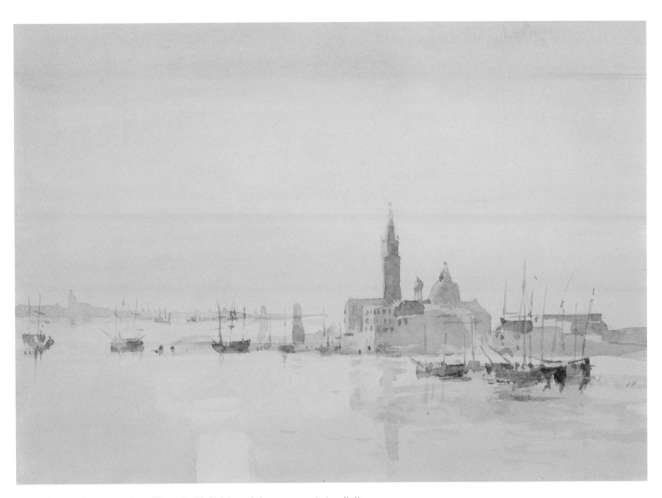

7. The finished painting is suffused with light, and the apparent simplicity
and restraint of Turner's painting method is masterfully understated.

Painting Water 1

Tony Smibert

Sea study in opaque wash on coloured paper

Turner was a close observer of the sea, and often made his brushwork a critical element in capturing its many moods. As a preliminary exercise, try making rapid wave studies by dashing down the rise and swell of waves with the side of your brush. Rather than consciously drawing the waves, try to feel them and let the brush move lightly across the paper, as if dancing across the surface of a storm-tossed sea. You can also experiment with various ways of picking up the paint from your palette: in this exercise my brush was too wet and I ended up with solid marks rather than the light, textured marks found in Turner's studies of waves. However, as the brush dried the marks became lighter.

Below left:
J.M.W. Turner
The Breaking Wave ?c.1832
Gouache and watercolour on blue paper
19.2 x 27.9
Tate

Below right:
J.M.W. Turner
Waves Breaking on Shore c.1835–40
Watercolour and gouache on blue paper
19.5 x 28.4
Tate

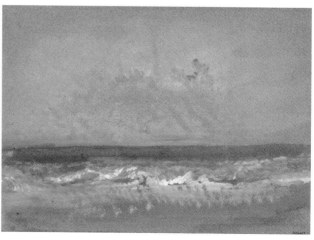

1. Start by wetting the coloured paper thoroughly on both sides. Smooth it onto a flat surface and use a clean, wet brush, moving outwards from the centre towards the edges, to remove any bubbles beneath.

2. Using an opaque gouache wash, sweep in the foreground with a cadmium yellow and raw umber (or whatever colours you choose). Work fast and free and allow your brush to leave the paper (though not necessarily as much as above!) Then use a single pass of a brush loaded with cobalt blue to suggest the ocean beyond.

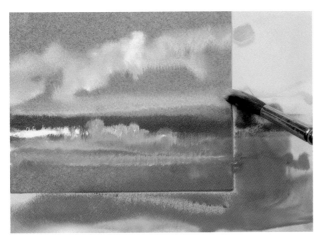

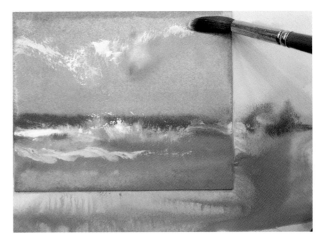

3. Straight away scumble* the wave forms with opaque white. Use colour picked up from the foreground when you scumble the clouds, as this will help to unify the composition.
*See p.138 for definition

4. Finally, as the sketch dries, use pure titanium white to add crisp elements to the waves and upper edges of the clouds.

Painting Water 2

Tony Smibert

Painting a choppy sea

Many of Turner's most evocative studies of the sea are very subtle in execution and involved his working on them at different stages while the paper was drying. Sometimes they are preserved at the preliminary stage or in much more fully developed watercolours, like his dramatic view of Sheerness below. You can see how these wonderful studies, evolved from Turner's immediate responses to nature, laid the foundations for his more complicated designs.

Below:
J.M.W. Turner
Sheerness c.1825
from *The Ports of England 1826–1828*
Watercolours
Pencil and watercolour on paper
16.1 x 24
Tate

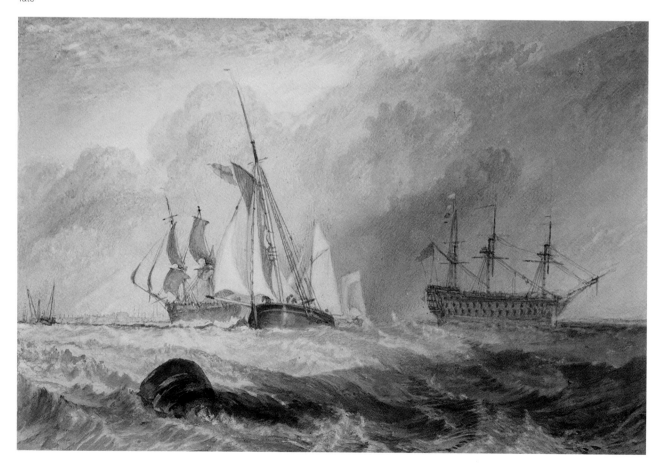

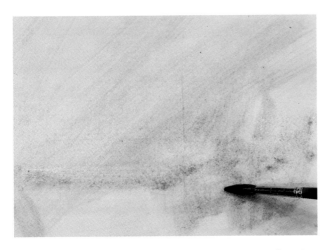

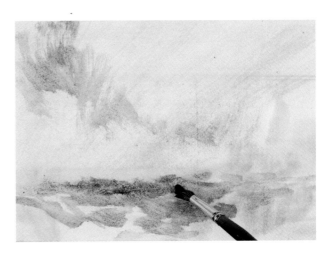

1. Using cartridge paper, wet and smooth a sheet onto a board or table top, then suggest a glowing light within sea mist by laying very little colour (I used raw umber) in a few sweeping strokes across the sky, which also indicates the direction of the light. Then, using a few touches of Indian red, immediately suggest a distant headland, barely seen through the mist.

2. Continue to work on it, noting that, as your brushmarks become less softened due to the drying of the paper, they can now be used to suggest broken clouds above and waves below. Using the same pigment and tone for both will act as a unifying element across the composition. You can then build deeper tone into any area where you want to strengthen the composition.

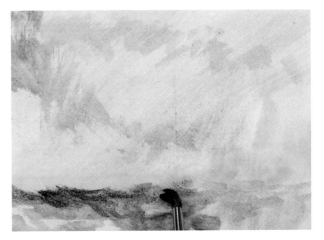

3. Many of Turner's effects suggest that he used the heel of his brush both to drag and to push pigment into a variety of unexpected marks, evocative of clouds and waves.

4. The tip of the brush can still be used whenever you need to create crisper details or edges. Such studies give you the opportunity to orchestrate quite subtle effects into paintings that are as much about the art of watercolour and colour harmony as they are about the ocean.

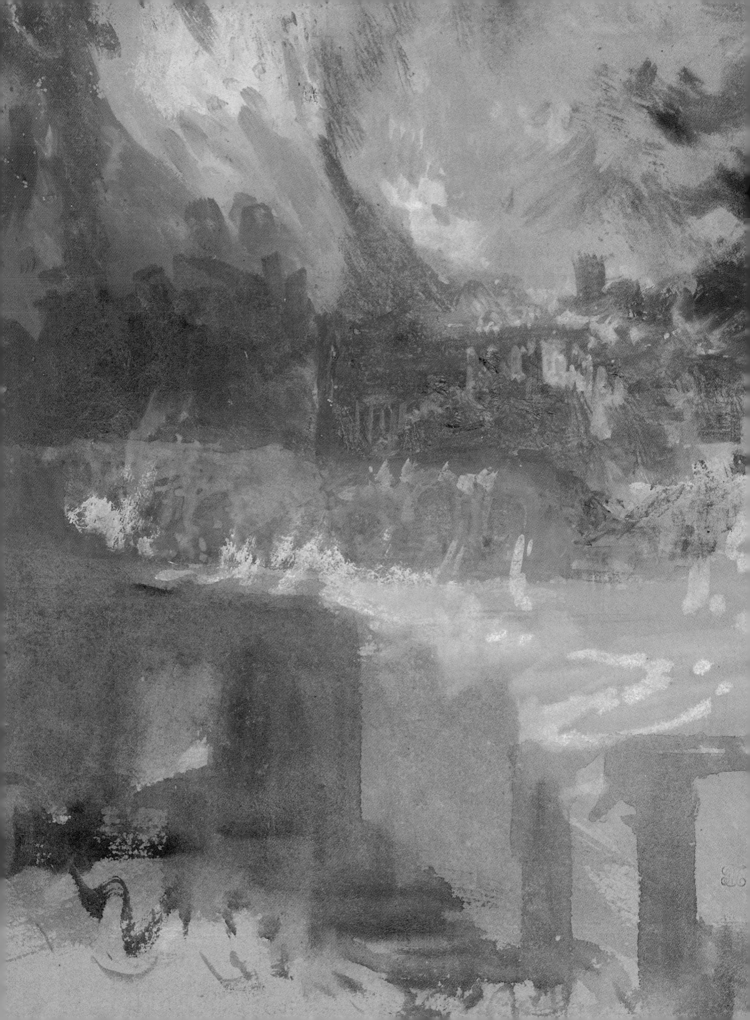

Fire

Turner painted comparatively few images of fire, but his unforgettably powerful evocations of the burning of the Palace of Westminster in 1834, which destroyed the Houses of Parliament, in oil and watercolour, are now among his most celebrated works.

Even as a young artist, Turner had been alert to the very distinct qualities of firelight, noticing how it eerily transformed a familiar setting by illuminating some surfaces brilliantly, while casting others into impenetrable darkness. From his studies of the paintings of Rembrandt or more recent artists, like Joseph Wright of Derby or Philip Jacques de Loutherbourg, Turner found that such effects were easily achieved in oil on canvas, working from a dark ground, with the lighter passages added towards the end of the process. By contrast, in watercolour, he learned with practice how to reserve areas of his white paper for the most dazzling parts of his design. He combined something of both techniques in an unfinished study of Rome, applying watercolour to a sheet of brown paper, and adding white highlights to intensify the effect of light flickering across the marble temples (left). The study uses the barest means to block in a swathe of destructive crimson flame, its topographical element, a group of darkened silhouettes, amounting to the simplest indistinct suggestion of Rome. Yet all of this is sufficient to be highly potent as a realisation of the familiar idea of ancient Rome being laid waste by fire because of the neglect of its leaders.

A similar perception of political ineptitude and corruption lies at the heart of Turner's paintings of the burning of the Houses of Parliament. The devastating fire took place on 16 October 1834 during a decade in which reformers were pushing through measures aimed at bringing parliamentary procedures up to date and making them more truly democratic. Ironically, it was the unsupervised burning of old wooden tallies, used in accounting methods of the time, which started the fire that rapidly took hold of the complex of historic buildings. Thankfully, the direction of the wind changed before the fire could destroy Westminster Hall, with its great hammerbeam roof.

Several accounts confirm that Turner was among the huge crowds that witnessed the spectacular visual drama of the fire and the operations of the fire crews, as they attempted to limit its damage. What is less precisely documented is the nature of the observations

he made on the spot. Apparently he spent some of the evening in a boat, enthralled as the flames rose upwards. But the viewpoints in the two oil paintings he subsequently exhibited place him among the throng near Westminster Bridge and then further downstream towards Waterloo Bridge. There is also a series of nine watercolour studies, formerly in one notebook, that chart different stages of the fire. These vivid impressionistic scenes have sometimes been claimed as a kind of documentary journal of the fire's progress, but it is unlikely Turner could have worked directly from his subject in such circumstances. More probably, he plundered his memories of the evening once he had time to reflect on the event, back in his studio. Similarly, his most developed depiction of the fire, showing the fire crews' heroic efforts to save the buildings surrounding Palace Yard, can be traced back to pencil sketches in a small notebook (above), which may in fact not have anything to do with the events on 16 October 1834. IW

How to Paint
The Burning of the Houses of Parliament

Mike Chaplin

This watercolour is a real essay in the power of simple, vigorous colour. The subject is enhanced by the emotional feel that warm colours always engender. 'Lifting-out' seems to be the ideal technique to introduce the shimmering light areas of the lit-up façade and the water jets.

**Colours used
in this exercise:**

Cadmium red

Burnt sienna

Lemon yellow

Cobalt blue

Permanent magenta

Burnt umber

Below:
J.M.W. Turner
The Burning of the Houses of Parliament ?1834–5
Watercolour and gouache on paper
30.2 x 44.4
Tate

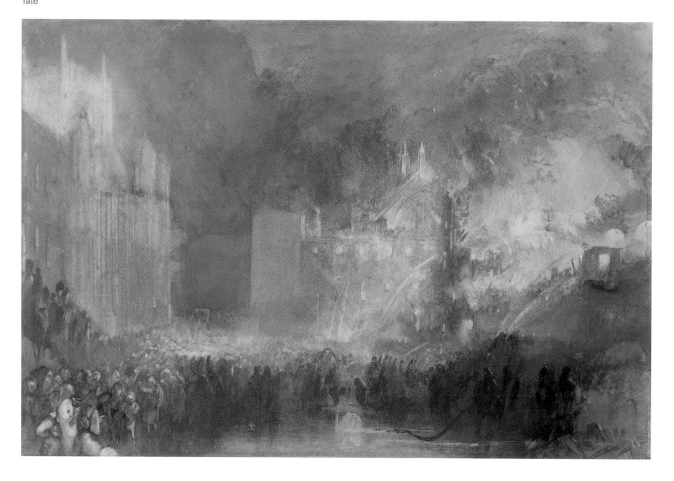

1. Take a piece of dry gelatine-sized paper and begin by vigorously applying uneven washes of cadmium red with a flat sable brush.

2. Lay in a vertical stroke of granulating cobalt blue to define the edge of the Houses of Parliament, on the right, and the night sky. Allow this to mix in places with the red to produce purple undertones.

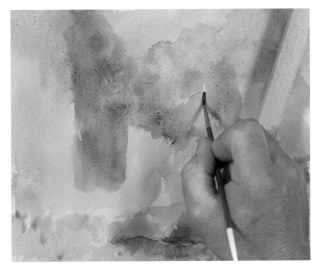

3. The building on the left is Westminster Abbey. To create the underlying tones of this structure you need to mix cobalt blue and cadmium red. Then brush in some burnt umber in the foreground as the base for the figures.

4. Next, strengthen the cadmium red at the heart of the fire. While this area is still wet, colour can be lifted out using a barely moist brush. Very wet paint will always be drawn up into a less wet brush (capillary action) and a good sable brush has a huge water-holding capacity because the individual hairs are slightly rough.

exercise continues overleaf

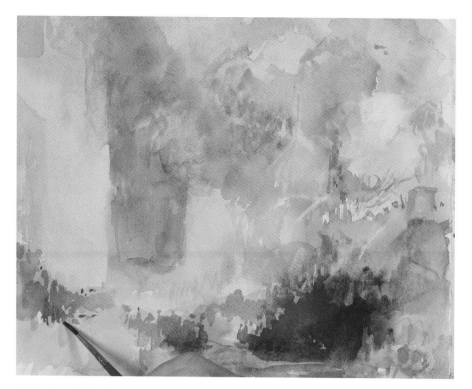

5. Continue to lift colour out to create architectural details and the jets of water from the hoses, beginning at the same time to indicate the groups of figures watching the event.

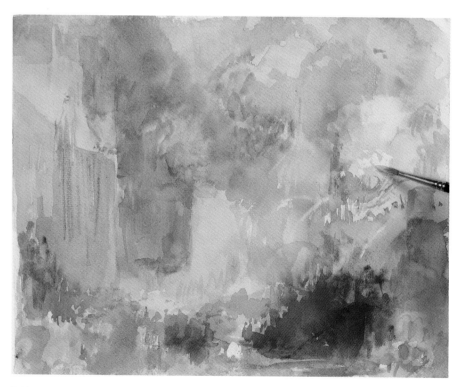

6. You can use opaque white to pick up highlights in the fire and on the waterspout in the central foreground.

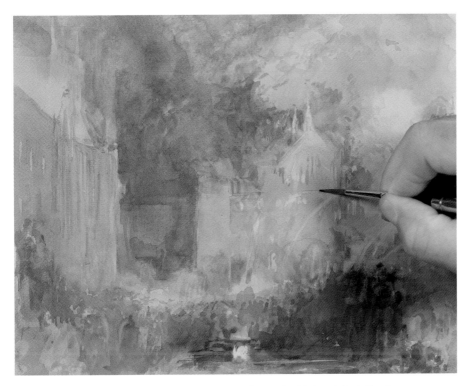

7. As you get close to finishing the image, use a small round sable brush to define the architecture and to give a sense of motion to the projected water. The figures should be left rather indistinct, with only minimal touches to differentiate them.

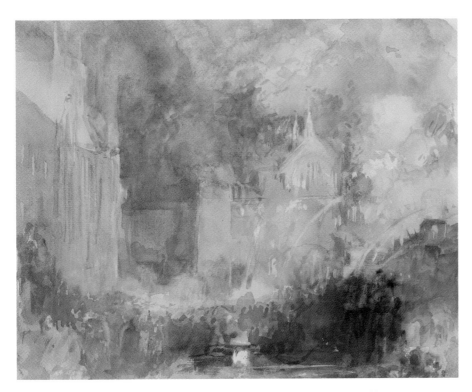

8. Although Turner's watercolour is in fact a considered response, painted later in his studio, he imbues it with the urgency of the situation. Very skilfully, he used a bold technique, suggestive of fluent brushwork and sharp observation, to conjure up a sense of witnessing at first hand the actuality of this landmark event.

Painting Fire 1

Tony Smibert

After Turner witnessed the burning of the Houses of Parliament in 1834, he turned to watercolour to jot down his impressions, digesting the experience by exploring numerous ways of portraying the drama. These works reveal his capacity to work fast, to think in terms of colour, and to experiment with possibilities.

Aware that my own studies are often much less atmospheric than Turner's, I wanted to achieve a softer appearance. The paper you use can make a great difference, so this time I used a harder, less absorbent cartridge paper than usual. I also painted softer passages of wash and used more blending.

Below:
J.M.W. Turner
The Burning of the Houses of Parliament 1834
from *Burning of the Houses of Parliament (1)* sketchbook
Watercolour on paper
23.2 x 32.5
Tate

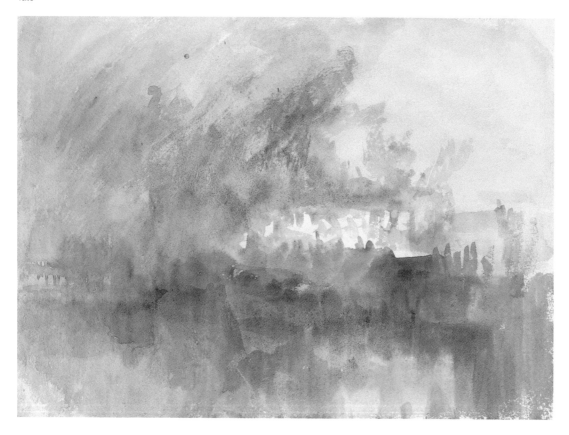

1. For my study, I imagined a fire seen across a river in the heat of summer. To begin with, lightly wet the page and then dash down the character of the blaze as it leaps into the sky using your imitation sable brush. Perhaps strengthen the effect with more powerful passages of wash (I used light red, warmed with cadmium red).

2. Next, paint the sky beyond, where it meets the edge of the flames (I used cobalt blue). This will help to define the reach of the flames. Loosely mirror this in the lake or river. Work fast and free – let the accidental character of the brushmarks become a part of your image. Try strengthening the flames with a yellow.

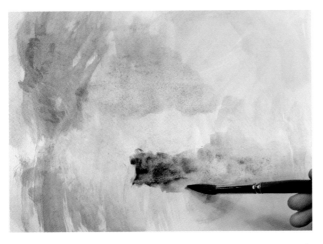

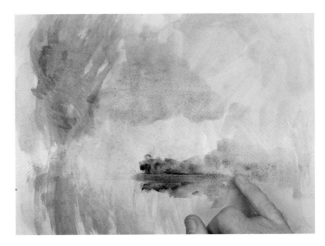

3. As the paper dries, strengthen the flames further with flicks of a stronger red from the tip of the brush. Finally, the foreground is finished with a shadowed promontory jutting out from much closer to the viewer and painted with a grey made of a mix of warm and cool colour used elsewhere, here the light red and the cobalt blue.

4. An easy way to finish the foreground reflection is by wiping away the wet paint with a finger, adding a strong horizontal feature.

Painting Fire 2

Tony Smibert

Turner's studies of the burning of the Houses of Parliament might appear simple, but they are in fact highly complex masterpieces. Keep your own studies very simple at first and perhaps start by painting abstract colour patterns on a dry paper using soft washes of warm and cool colours. Remember to reserve patches of white here and there, both at the heart of the fire and elsewhere throughout the composition. Wonderful effects will often occur by accident too, enlivening your picture. Try to work very fast and move quickly from one study to another, as Turner would have. The more studies you do, the more confident you will grow.

Below:
J.M.W. Turner
The Burning of the Houses of Parliament, from the River 1834
from *Burning of the Houses of Parliament (1)* sketchbook
Watercolour on paper
23.2 x 32.5
Tate

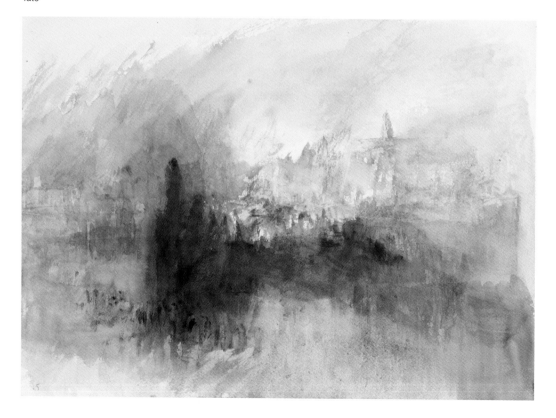

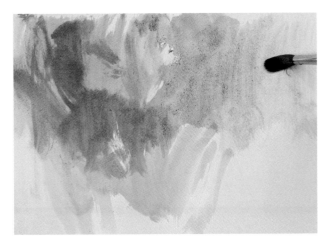

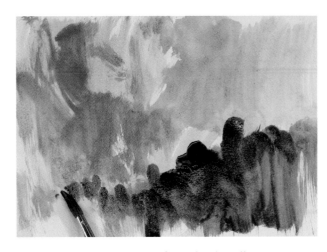

1. Having witnessed a bush fire, I wanted to create the effect of flames blazing above a forest of trees as might be seen from a nearby hill. Again, working solely with my imitation sable brush I began by using yellow ochre, which I strengthened with more powerful passages in light red, warmed with cadmium red.

2. Next, using a brush or your fingertips, broadly suggest a dark forest running down the hillside. Build up the trees more strongly in the foreground, and show them disappearing into the distant blaze as your brush runs out of pigment.

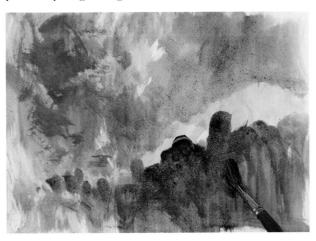

3. While the flame area dries, squeeze the brush out and use it moist (not wet) to pick up red from your mixing palette. The splayed tip of the brush will help you achieve some of the sorts of marks that Turner accomplished. Use some of the same red to enliven the nearby forest.

4. Finally, lights can be removed from within the flames using the edge of a knife blade to push the paint aside in areas that are still wet.

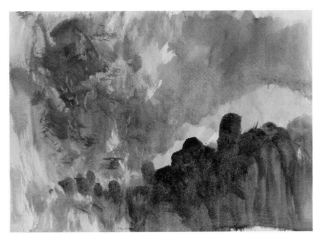

5. Rapid colour studies like this would have taken Turner only minutes to paint, but were an invaluable part of his working system, both as a means of recording impressions and as a way of testing effects for later works.

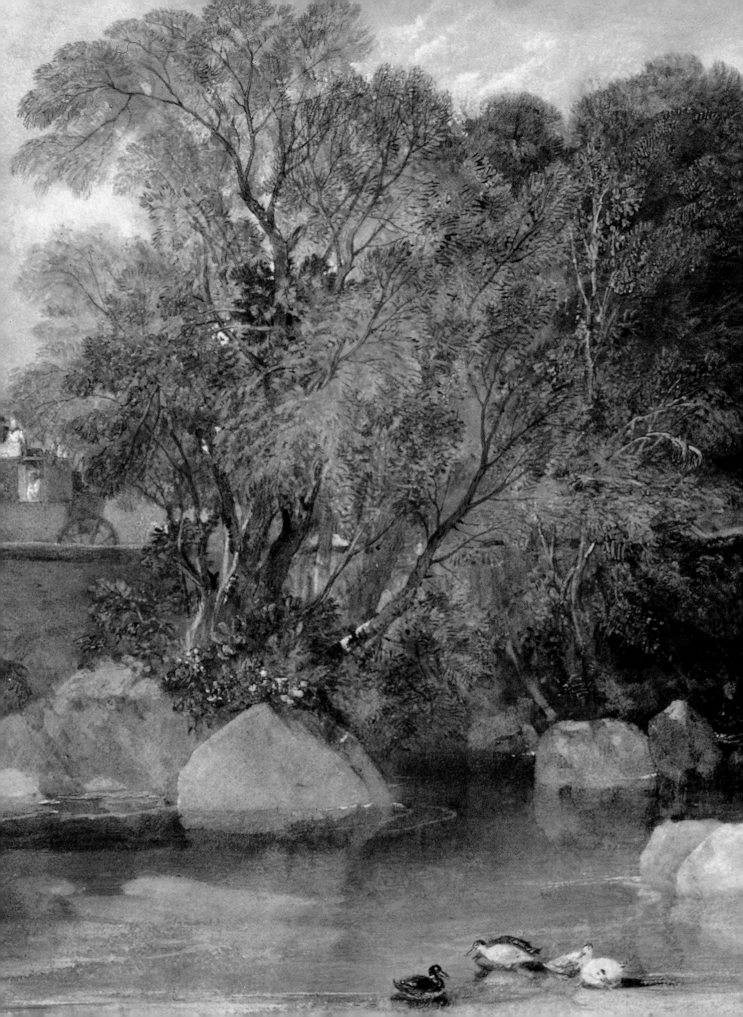

Trees

Turner's depiction of trees combines close observation with his own imagination. He rejected the stylised methods of representing foliage popular in the eighteenth century in favour of a more naturalistic approach, but at the same time he was not a slave to botanical precision. Instead he was more interested in arboreal artistry: the general impression of dense vegetation, dappled by light and shade, or the elegant grandeur of arching branches gracefully framing the foreground of a composition.

Left:
J.M.W. Turner
Ivy Bridge, Devonshire c.1813 (detail)
from *Rivers of Devon*
1815–1823 Watercolours
Watercolour on paper
28 x 40.8
Tate

Below:
J.M.W. Turner
A dried skeleton of a leaf
from *Boats, Ice* sketchbook 1806–8
10.7 x 18
Tate

Turner's watercolours exhibit a wide variety of touches, from the broadest washes to the most detailed stippling, and he was not afraid to try unorthodox methods in pursuit of the right effect. Certainly there is nothing formulaic about the use of paint in *Study of Trees* (see p.84). Here Turner is instinctively searching for the most cogent means of reproducing bark and leaves, combining thin wet washes with dry, feathery brushwork. In certain patches he has directly used his fingers to manipulate the wet paint, leaving visible prints in the tacky surface. The naturalistic authenticity of the image is enhanced by the man in the bottom right-hand corner, wearing an outdoor hat and coat, and drawing or painting in a brown leather sketchbook. Perhaps this nondescript figure is intended to represent the artist himself, in the very act of communing directly with nature? A couple of his sketchbooks certainly contain leaves still pressed within their pages, more than 200 years after the artist first placed them there (right).

Some of the freshest and most immediate studies of trees date from 1805, when he spent a summer exploring the River Thames and its tributaries. Accustomed as he was to sketching outside in pencil, on this occasion he also experimented with painting out of doors. Much of this *plein-air* work was done with oil, but the trip also marks Turner's first use of a 'roll' sketchbook, a fairly large book bound with soft paper covers for on-the-spot watercolour painting. The earthy vibrancy and spontaneity of some of these Thames studies evoke perfectly the cool freshness of English woods and river banks, and suggest the closest possible link between the artist's hand and eye, and the subject before him (see p.88).

As a devotee of the natural world, Turner's paintings often feature woods and forests, particularly in his portrayal of the countryside, which his contemporary, William Blake, would famously describe as 'England's green and pleasant land'. Some of his finest and most accomplished achievements were his mid-career topographical watercolour schemes, which were serialised as collectable engravings and formed a pictorial survey of the nation from coast to coast. In views such as *Ivy Bridge, Devonshire* (left), part of an unrealised project called 'The Rivers of Devon', Turner demonstrated his complete mastery of the texture, forms and colours of massed foliage. These trees, however, represent more than just background scenery. Turner imbues them with character and vitality, symbolising the very spirit and essence of the English landscape. NM

How to Paint
Study of Trees

Mike Chaplin

This study uses several different techniques to achieve its effects, and much can be learned from copying the loose and textural handling of the paint. The underlying washes need establishing before you get involved with detail.

Below:
J.M.W. Turner
Study of Trees c.1820–30
Pencil and watercolour on paper
27.4 x 18.8
Tate

**Colours used
in this exercise:**

Cobalt blue

Burnt sienna

Ivory black

Permanent mauve

Lemon yellow

1. Lay down a minimal outline drawing using a charcoal pencil (or soft pencil) on a rough-textured, off-white heavy paper.

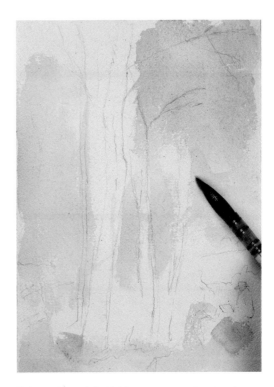

2. Loosely wash light-blue areas over the drawing to establish background coolness behind the trees. Use a large wash brush, for example a no.10 pointed sable brush, and work freely.

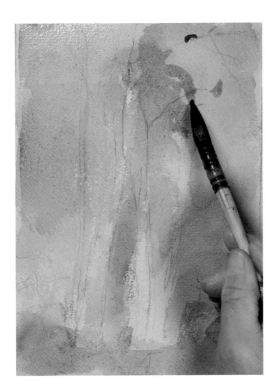

3. Now brush a warm colour wash, using burnt sienna, over the previous cool ones to indicate where the areas of foliage will be.

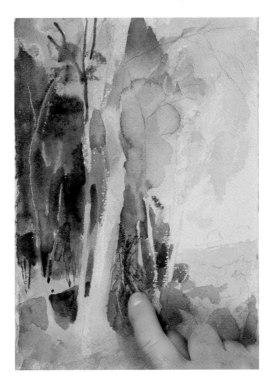

4. Place darker recessive washes in ivory black behind the trees to establish the trunks as light against dark areas. While the paint is still wet, scratch in the thin tree on the extreme left and the matter foliage in the centre.

exercise continues overleaf

85

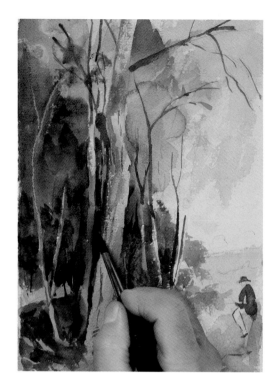

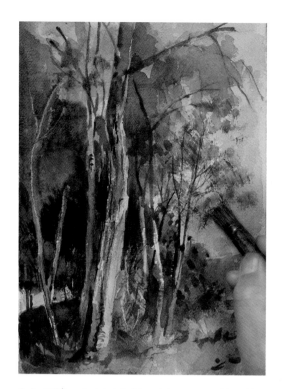

5. Using further dark tones, draw in (with paint) the areas between the trunks and branches. Lightly indicate the seated figure on the right.

6. A stiff (hog hair bristle) brush is now used to add the broken linear texture of the fresh green foliage with a mix of lemon yellow and black. Paint in the field and distant trees on the right, using lemon yellow and cobalt blue, and add detail to the trunks in the foreground.

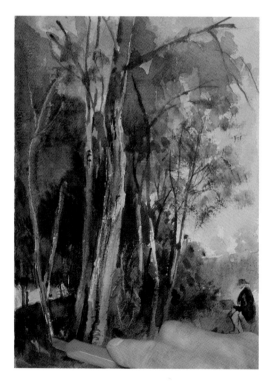

7. Using a sharp knife, scratch in any further highlights, for example at the bottom of the left-hand tree. Darken the body of the figure.

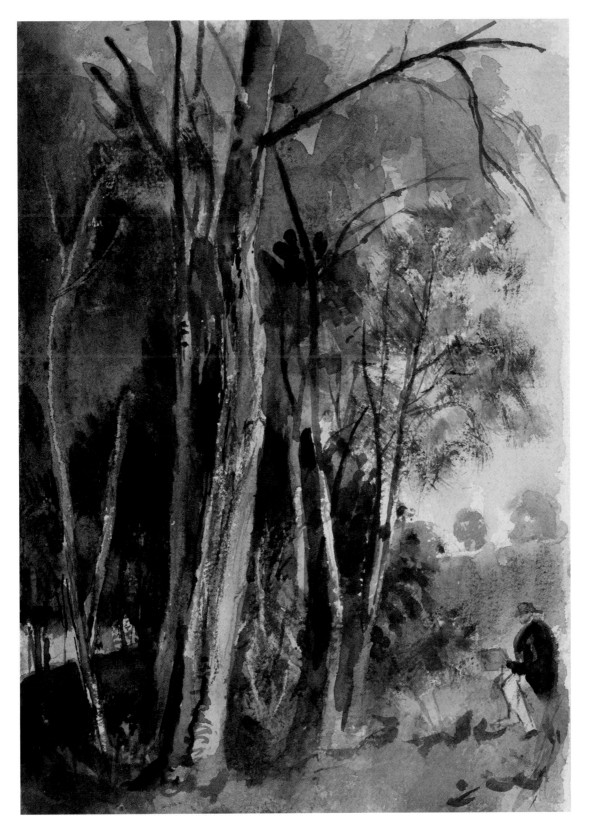

8. Slight adjustments in strengthening some of the tones and colours, and a few small additions to the branches, finish the painting.

Painting Trees

Tony Smibert

Turner's approach to trees

Turner's tree studies, especially his outdoor sketches, may look complicated but are often comprised of very simple marks, which were applied in a way that gave him enormous scope for creativity and a system for recording observations in the field. As his watercolour of trees by the Thames shows (below), sunlit foliage is visually comprised of light and dark areas. The colour and shapes required to represent autumnal foliage can be easily found in any palette in which you mix warm and cool colours, and the following exercise is a tonal study of trees using warm and cool washes with Turner's approach as a reference point for your own experimental studies.

Below:
J.M.W. Turner
Trees by the Thames: Richmond Bridge in the Distance 1805
from *Thames, from Reading to Walton* sketchbook
Pencil and watercolour on paper
25.7 x 36.8
Tate

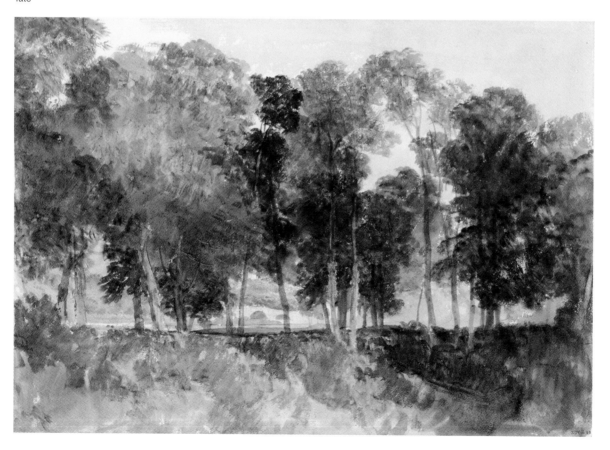

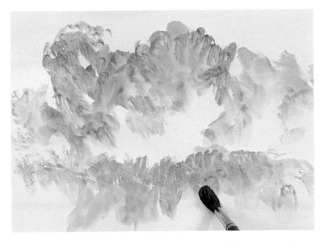

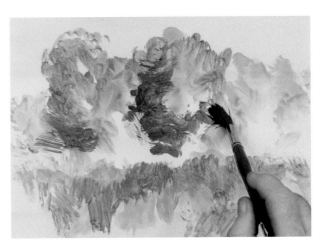

1. Using a dampened imitation sable brush, pick up raw umber from your palette and start to build up both the trees *and* the ground – the massed foliage and late summer grasses below.

2. Then move to burnt umber and build deeper passages of warmth on the shadowed side of one or two of the trees, and more shadow to the ground beneath.

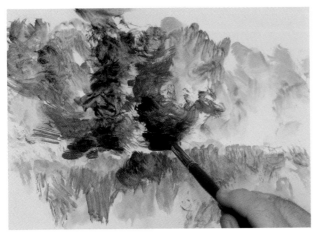

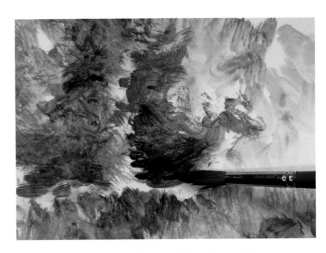

3. Now repeat the process using a dark, cool colour like Prussian blue (or add some Prussian blue to burnt umber) and build up the shadowed masses of foliage seen behind the sunlit trees in the front and also glimpsed *through* them.

4. Add very deep shadows here and there beneath the trees or, as I have, focus attention on one tree. Do remember to link the shadowed foliage to depths of tone on the ground in shadow below.

exercise continues overleaf

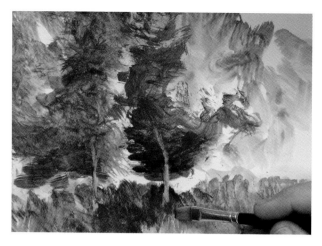

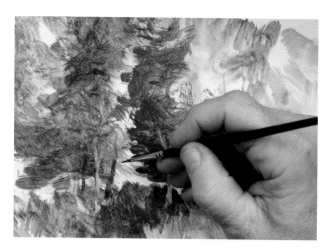

5. When all this has dried and depending on the type of paper you are using, one way to introduce light trunks would be by painting them using clean water, then lifting off the paint within the trunk using a dry tissue, blotting paper or clean rag.

6. Darker trunks can also be painted in using a fine brush and deeper shadows added to strengthen the composition.

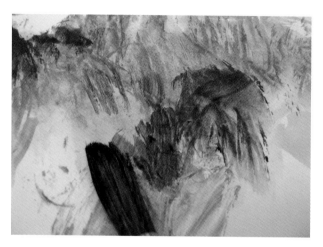

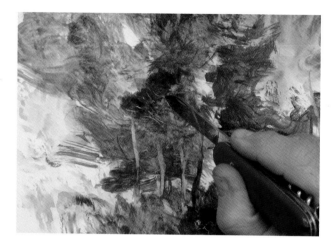

7. Use the tip of a large brush to press and scumble foliage and grass.

8. Tiny branches and leaves can also be scraped out of areas where the wash is still damp. This process will benefit from an understanding of structure, detail and shape acquired through sketchbook drawings.

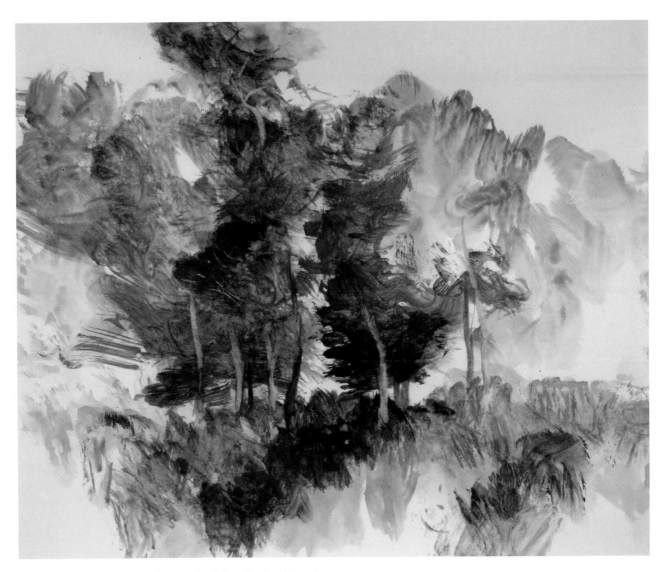

9. Remember that the final effect can be tight or lively. Although you are borrowing a system from Turner your brushmarks will always reflect your own energy. This creative exercise took only minutes, but you could of course take more time, working over a careful preliminary drawing to end up with a highly realistic watercolour study.

Buildings

Underpinning Turner's work as a topographical artist was his ability to record architecture precisely on his travels, and to render it effectively in his watercolours afterwards. Indeed, few of his landscapes are without some building or monument that catches the eye and adds meaning to his scenes. For this skill he was, undoubtedly, indebted to his early training as an architectural draughtsman.

From the age of about fourteen, he was employed to work from the plans of various architects to create attractive realisations of their proposed constructions. The process was important for Turner in teaching him how to give volume to the structures in his images through gradations of shade, as well as instilling in him the need for the hand to be able to replicate effortlessly what the eye sees, however fiddly and repetitive the architectural details may be.

Turner's apprentice years in the 1790s coincided with the fashion for all things 'Picturesque', an aesthetic taste propagated by William Gilpin (1724–1804), which embraced asymmetrical, broken forms and rough textures, and was epitomised by tumbledown cottages and the ruined abbey-churches laid waste in the Reformation. Many of the ambitious and increasingly large watercolours that Turner exhibited were renderings of popular tourist destinations, such as the abbeys of Tintern, Fountains or Kirkstall, or of the gravity-defying cathedral interiors of Salisbury, Durham and Ely (left). In addressing such subjects, Turner seems never to have been daunted by the difficulties of recreating interlocking spaces permeated by different types of light. In fact, he seems to have composed his images to make them as complex as possible, thereby enhancing the illusion of spatial depth.

By 1807, Turner's skill was officially recognised when he was appointed as Professor of Perspective at the Royal Academy. There was also a practical side to his interest in perspective, which informed the construction of a house for himself at Twickenham, and the subsequent modifications to his gallery in Queen Anne Street, north of Oxford Street in central London.

Architectural information also dominates Turner's pencil sketches. Those of a specific building are often exacting in their description of its individual parts. However, he was just as happy to sketch only one section of a façade, leaving the rest blank with merely a note of the number of times the aspect he had transcribed was repeated. Because his eye was so well trained through years of looking, the pencil sketches he made in the second half of his career are often less precise, relying on his memory to fill in the blank, or loosely observed, passages. But it is this solid body of observation that provided the foundation for all aspects of his work. In fact his diaphanous late watercolours are in most cases dependent for their compositions on forms Turner had already recorded much more attentively. IW

Left:
J.M.W. Turner
Ely Cathedral, South Transept ?exh.1797
Watercolour on paper
62.5 x 48
Aberdeen Art Gallery & Museums Collection

Top:
J.M.W. Turner
The Rio San Luca alongside the Palazzo Grimani, with the Church of San Luca c.1840
Gouache, pencil and watercolour on paper
19.1 x 28.1
Tate

Above:
A view of the Rio San Luca from the Grand Canal, 2002

How to Paint
Blois: The Façade des Loges of the Château from Below

Mike Chaplin

Turner creates a vertiginous feeling in this image by choosing a viewpoint where the sharp angle of the wall accentuates the strength of the building. The architectural detail, although complex, is drawn with a light and fluent touch. Comparing the finished colour study with the very basic sketch Turner made on the spot reveals the extent to which he could transform his materials imaginatively.

**Colours used
in this exercise:**

Titanium white

Ivory black

Burnt sienna

Lemon yellow

Cadmium red

Cerulean blue

Below:
J.M.W. Turner
*Blois: The Façade des Loges of the Château
from Below* c.1828–30
Watercolour, gouache and pen on blue paper
13.8 x 19.1
Tate

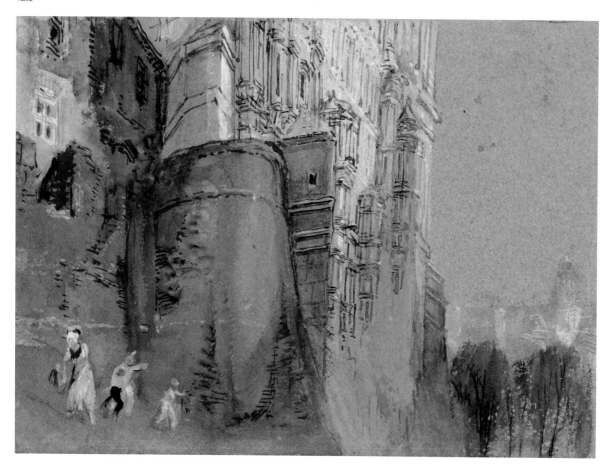

1. You will need a sheet of mid-toned, blue pastel paper. On your sheet of blue paper, faintly sketch out the principal masses of the architecture. Give these areas substance by laying in the first washes of semi-transparent white and grey using a large pointed sable brush.

2. For the contrasting warm colour of the tower on the left, apply a burnt sienna wash using a soft flat wash brush. At the same time add a generalised blur in the bottom right for the foliage of the trees. Then work wet-in-wet with cadmium red to create the stronger areas.

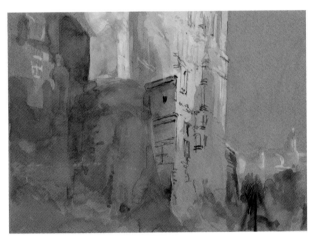

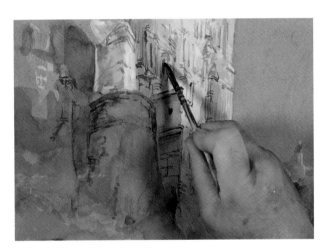

3. Use a very fine long-haired brush – or 'rigger' – dipped in grey to start putting in the first architectural details. You will need to use a darker tone to replicate the wiry strokes Turner used for the tree trunks and branches.

4. For the chateau's windows, select a larger brush, moderating the strength of the grey as you move across the façade.

exercise continues overleaf

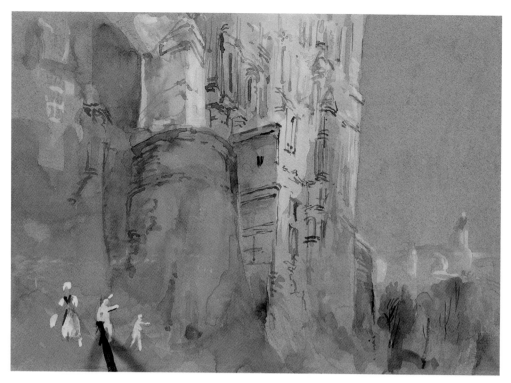

5. Set out the basic underlying shapes of the figures using opaque titanium white. You will find it easiest to sketch all of the figures very generally in one go, and then refine them later. Add detail to the figures, working on all of them first with black, then cerulean blue, and finally with red.

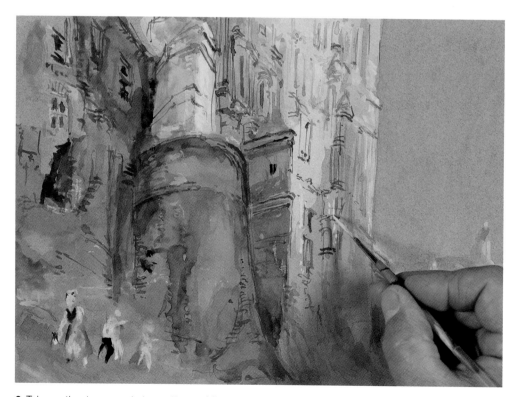

6. Take up the rigger again to continue adding more precise detail, dipping the brush this time in warm brown watercolour to make light, fluent marks. Finally, add white highlights to the sunlit face of the building.

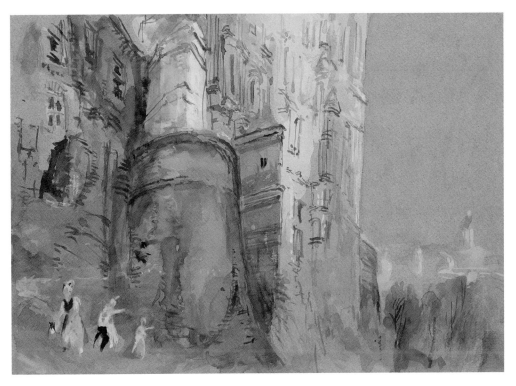

7. The final version highlights how skilfully Turner opposes warm
and cool areas in his images.

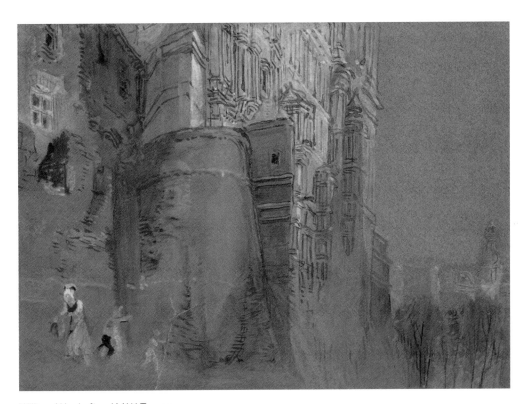

William Ward after J.M.W. Turner
Château de Blois, watercolour on paper, 13.4 x 18.3
Whitelands College, Roehampton
This watercolour, with all its challenges, also appealed to Ruskin's protégé,
William Ward, who was lucky to find his labours met the critics approval.

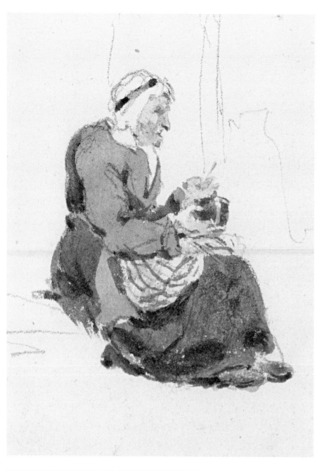

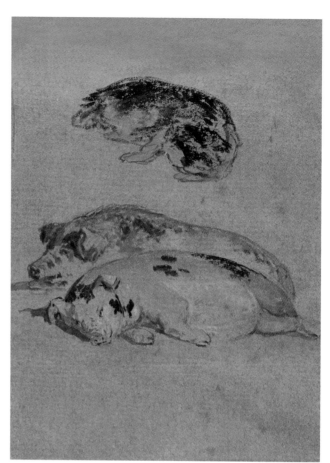

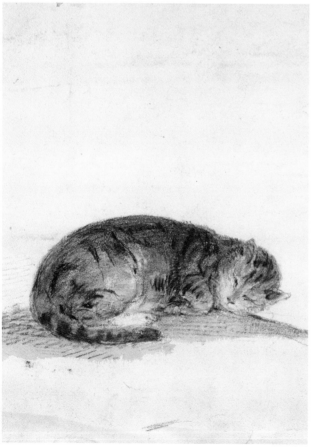

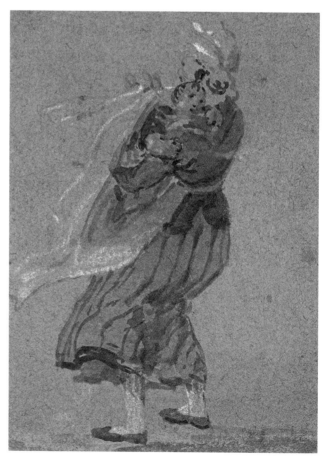

People and animals

Although Turner was first and foremost a painter of landscape, representations of people and animals are key components within his works. Based upon close observation of contemporary life, they reveal Turner's empathy with humanity and keen engagement with the world in which he lived.

Sometimes incidental details of fauna and figures are treated like a compositional device, designed to enliven the foreground or define a sense of scale. On other occasions they form an integral part of the theme or subject: for example, in the bustling scenes of everyday life in the artist's topographical watercolours of coastline and countryside, or the mythical and historical characters of his literary vignette illustrations. Finally, they could also underline or define the expressive power of a work, their moods or actions mirroring the ambience of their environment. The gentle presence of cows within a pastoral landscape, for example, suggests the untroubled harmony of an Arcadian idyll, but the motif of fishermen tossed around on a stormy sea represents the vulnerability of man at the mercy of the elements.

Like all aspiring students who passed through the doors of the Royal Academy Schools, the young Turner received a thorough grounding in the discipline of life drawing. However, in his subsequent treatment of the human figure he chose to abandon strict academic proportions in favour of a more homely, faintly whimsical approach. He developed his own distinctive figurative style, characterised by squat bodies, doll-like limbs and round 'currant-bun' faces, which sometimes seems at odds with the bewitching naturalistic beauty of his landscapes. Yet he had an undeniable talent for picturing humanity. Wherever he went he made swift records of moments witnessed in everyday life. His artistic eye was attuned to incident and detail across the gamut of human experience (left). Despite their economy of line and sparing use of colour, these sketches are full of character and life, capturing the physical essence of old age in the hunched shoulders and jutting jaw-line of an elderly woman or the tender clasp of the mother protecting her baby from a gusty wind. There is a similar vivacity present within his sketches of animals and birds. The individual attributes of each species are precisely inferred through form and texture. Compare, for example, the self-contained contentment of a sleeping tabby cat with its tail carefully curled around itself, with the corpulent abandon of the dozing pig, with its wrinkled snout and smooth tight belly.

This chapter features two alternative techniques for the representation of swans. In a swift sketchbook study, Turner has used feathery white gouache against a coloured washed ground to capture the pristine, sinuous elegance of these magnificent birds. However, for an incidental flurry of movement within the foreground of a view of Syon House and Kew Palace, the use of gum arabic preserves the pale form of a charging swan against the dark backdrop of the verdant riverbank. NM

How to Paint
Study of Two Swans

Mike Chaplin

Keep this lively study simple and try to imagine (and emulate) how long Turner took to do it. Draw and paint as fast as you can, to try to capture the excitement of the splashing birds. You might have to have several attempts!

Colours used in this exercise:

● Burnt sienna

○ Titanium white

● Ivory black

● Cadmium red

Below:
J.M.W. Turner
Study of Two Swans 1798–9
from *Swans* sketchbook
Pencil on paper
17.4 x 12.5
Tate

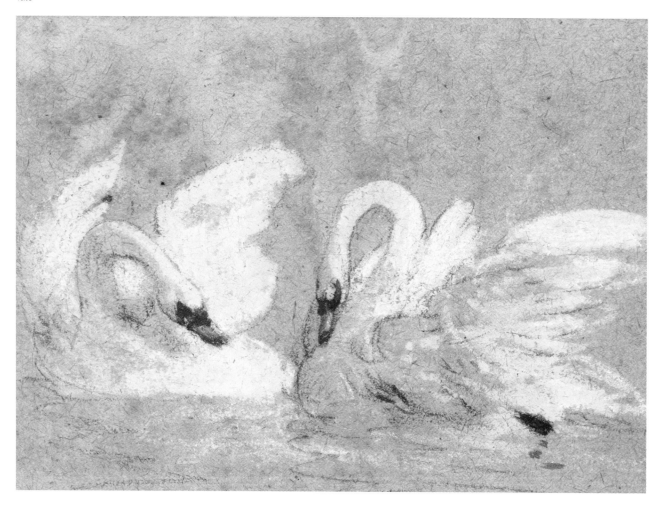

1. Prepare some pastel paper with a wash to simulate the rough, buff-coloured ground of Turner's sketchbook page.

2. Sketch the outline of the birds vigorously. The drawing should aim to capture the excitement and immediacy of the sketchbook study.

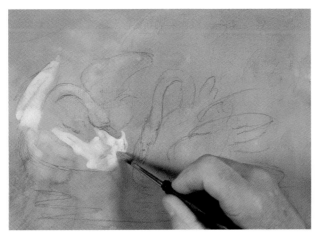

3. With a large sable brush begin to block in forms using opaque titanium white. The wash will sink in fast on a thin lightly sized paper and several applications may be needed to build up the desired strength of opaque white.

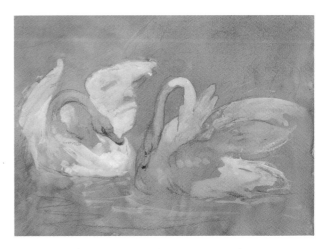

4. A variety of paint density adds excitement and a sense of movement to the image.

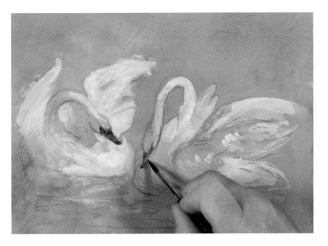

5. Strengthen some of the drawn lines with fine brushwork and add the red accents to the beaks.

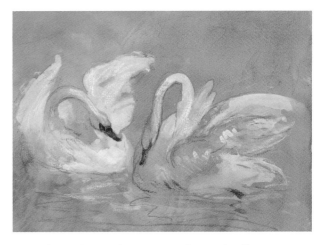

6. The finished study demonstrates the simple effectiveness of using a mid-toned paper and working both lights and darks as positive actions.

Painting Animals

Mike Chaplin

Painting with gum arabic

Gum arabic is a water-soluble gum that can be used to form a barrier to preserve highlights or pale forms within a watercolour (see p.24 for its other uses in watercolour painting). Unlike a wax-based resist technique, which leaves a paint-resistant film, it allows further addition of colour to the same area. The modern equivalent is latex masking fluid. Try experimenting with both methods to add figures, animals and other foreground details to your paintings.

Below:
J.M.W. Turner
Syon House and Kew Palace from near Isleworth ('The Swan's Nest') 1805
Watercolour on paper
68.4 x 101.3
Tate

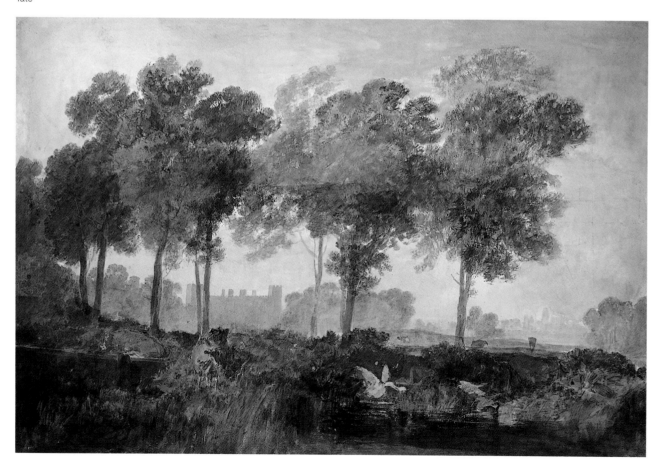

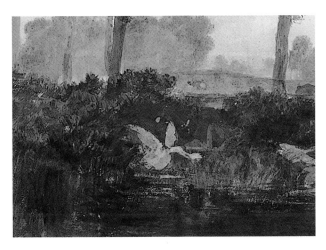

Detail of a swan from *Syon House and Kew Palace from near Isleworth ('The Swan's Nest')* 1805

1. On a smooth paper, use a large sable brush to paint the area to be protected with gum arabic in the shape of a swan. Allow it to dry thoroughly.

2. Apply a dark wash of warm browns with fast strokes from a fully loaded flat wash brush so as not to disturb the gum. As an alternative approach Turner sometimes favoured dipping the paper. Allow the wash to dry.

3. Place the dry painting in a shallow bath and pour clean water over it. The gum will dissolve and lift the overlying paint to reveal the masked shape underneath.

4. The swan is now fully apparent and the paper can be lifted from the bath and excess water drained off.

5. At this stage the image may be complete, or further painted detail can be added to the swan.

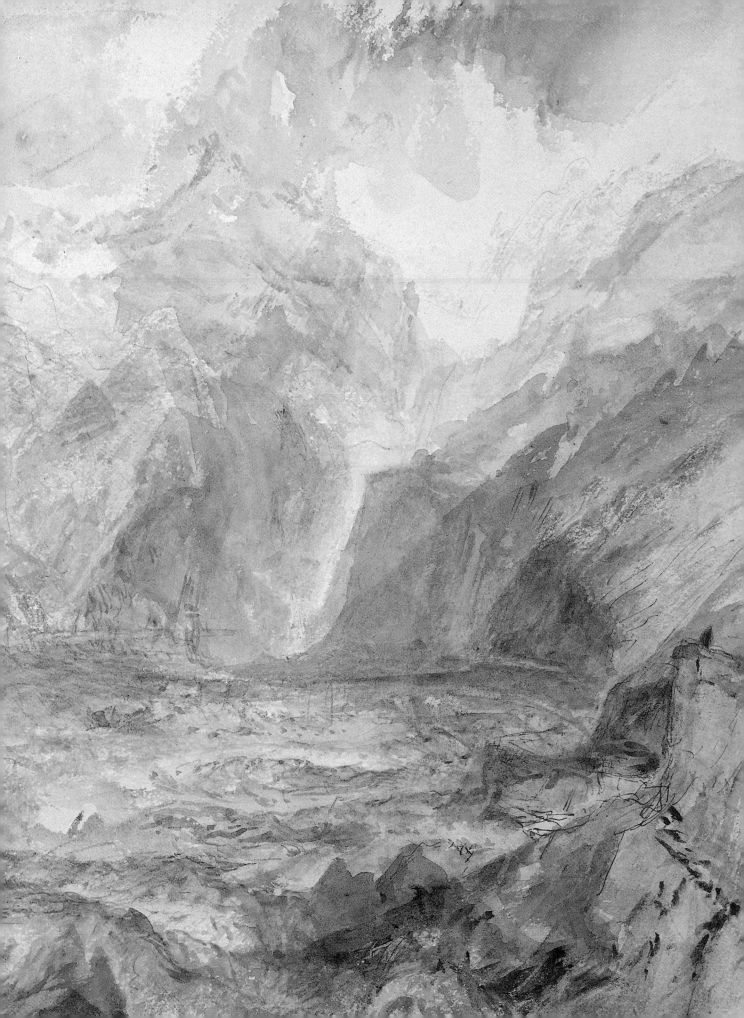

Mountains

Mountains are among the greatest visual spectacles that nature has to offer the landscape painter. During the late eighteenth and nineteenth centuries they came to epitomise the theory of the 'Sublime', an aesthetic that valued vastness, wildness and awe-inspiring grandeur. Their appeal was based upon the experience of terrible beauty; the pleasures of an excitement spiced with danger and the thrilling insignificance of man in the face of elemental forces.

Turner made many journeys in search of mountains. Some of his earliest sketching tours, undertaken during his teenage years and in his early twenties, took him to the remoter regions of Wales, northern England and Scotland. Here, among the peaks of Snowdonia, the Lake District and the Highlands, he found dramatic and atmospheric conditions that inspired him to move beyond a local record of place, and reach for something altogether more expressive and powerful. Some of his most glorious early works were the large studies painted on individual sheets of paper in response to the mountains of north Wales in 1799. With their masterly depiction of naturalistic effects, these ambitious watercolours demonstrated a correlation between technique and experience that fused topography with a powerful sense of drama and history.

These domestic excursions merely served to whet Turner's appetite for mountainous scenery, and in 1802 he set his sights further afield and embarked upon his first trip abroad. Here, the experience of the British giants he had seen thus far paled into insignificance beside the sheer monumentality of the European Alps. Turner adjusted his artistic vision accordingly, and the stylistic leaps he made in response to the magnificent heights of Mont Blanc and the St Gotthard Pass provided one of the defining moments of his career. Studies such as *The Source of the Arveyron* (see p.106) are products of a successful marriage between technique and subject matter, in which the savage drama of the scenery is mirrored by the physicality of his approach. Paper pre-prepared with a grey wash provides a perfect tonal base upon which to build textural layers of watercolour and gouache, which the artist then manipulated by scratching, rubbing and even gouging the painted surface to describe icy Alpine streams coursing through the rocky terrain.

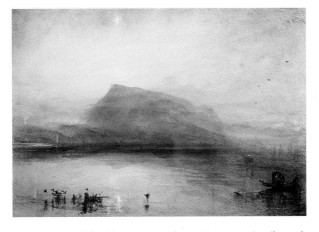

Turner revisited the Alps on several occasions, passing through en route to other parts of Europe, but sometimes making them the sole object of his trip, such as his extended exploration of the Valle d'Aosta in 1836 (see illustration on p.112) and his final tours of Switzerland during the 1840s. Although the landscape itself remained unchanged, Turner's ways of seeing did not and he constantly sought new ways to express the scale and splendour. In contrast to the dark and brooding solidity of his early work, his later watercolours describe spatial mass in terms of airy light and colour. Studies such as *The Pass of St Gotthard, near Faido* (left) render the ethereal, atmospheric magic of the mountains with pure washes of colour and subtle handling of paint on white paper. During the 1840s, the distinctive profile of the Rigi mountain rising above Lake Lucerne in Switzerland became a favoured motif that he revisited with reverential, even compulsive devotion (above). NM

How to Paint
The Source of the Arveyron

Mike Chaplin

A dramatic subject requires a dramatic style of painting, and this rocky landscape uses an array of techniques. Turner himself started by preparing a white sheet with a grey wash but you can also experiment with coloured papers. Scratching and scraping the paper creates effective texture within the mountainous terrain. You should be able to hear yourself working on this one!

**Colours used
in this exercise:**

⬤ Cobalt blue

⬤ Burnt umber

⬤ Neutral grey gouache

⬤ Ivory black

⬤ Permanent mauve

⬤ Titanium white

⬤ Hooker's green

Below:
J.M.W. Turner
The Source of the Arveyron 1802
from *St Gothard and Mont Blanc* sketchbook
Pencil, watercolour and gouache on white
paper prepared with a grey wash
31.3 x 46.8
Tate

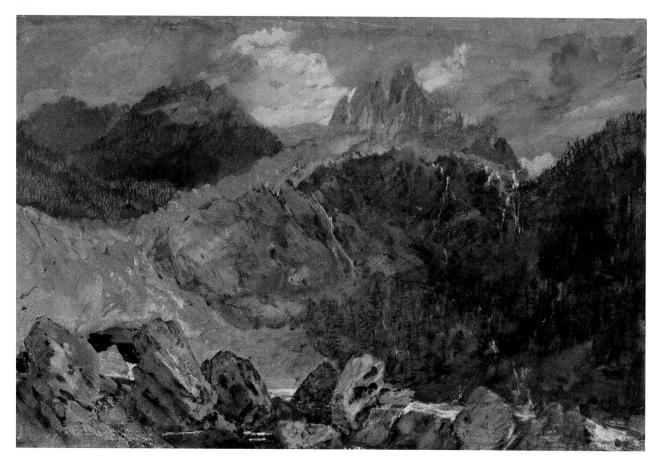

1. On a sheet of lightly toned buff or grey pastel paper lay in the outline drawing of the landscape. Start to build up the scene using a large pointed sable brush to create loose washes of cobalt blue and burnt umber to indicate warm and cool areas.

2. A neutral opaque grey gouache provides the base for strengthening the mountain peaks. Add touches of black, burnt umber and permanent mauve into the wet wash.

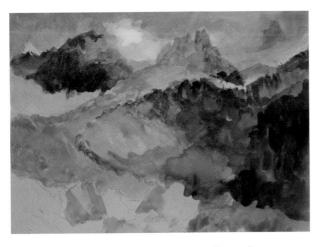

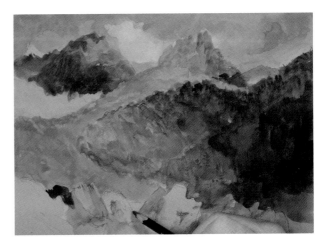

3. Now is the time to introduce extremes of tone. Opaque titanium white lightens the sky and the diagonal slope on the left. Conversely, the mountainside on the right needs to be considerably darkened.

4. Further define the rocks in the foreground using a charcoal pencil. Draw in the first trees in the middle distance with a fine brush.

exercise continues overleaf

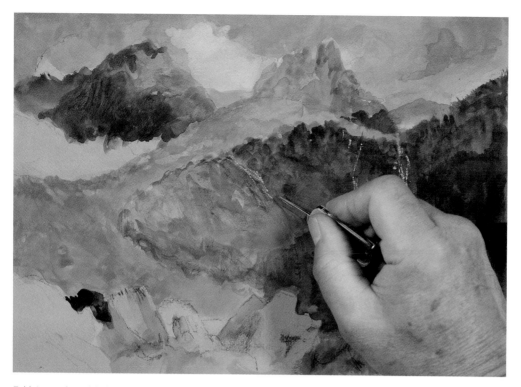

5. Using a sharp blade, scratch through the paper to reveal the sparkling white of the waterfalls. To do this the washes must be bone dry.

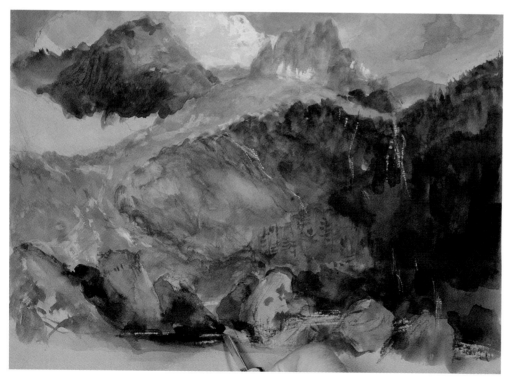

6. Add colour to the rocks and water in the foreground, and scratch in further light textures. Light areas can also be added to the peaks using opaque white with burnt umber.

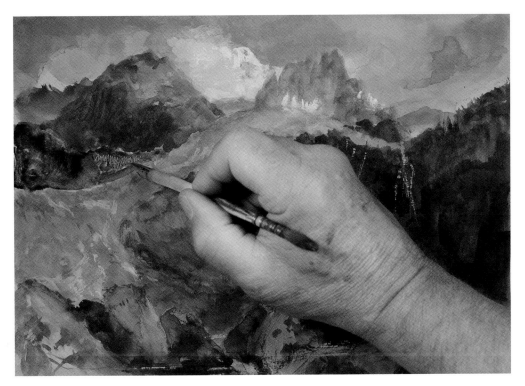

7. For the patch of forest on the left use a wash of black and Hooker's green thickened with gum arabic. While the paint is still wet, roughly scratch into it using a blunt tool (such as the quill of a feather or a drinking straw) to show the texture of the trees.

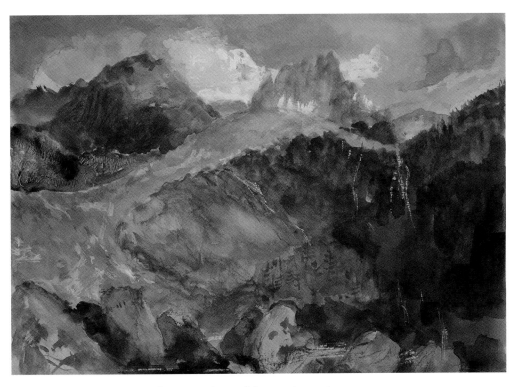

8. This heavily worked sheet of paper captures all the rough grandeur of an Alpine landscape.

Painting Mountains 1

Tony Smibert

Studies of mountains from sketches or the imagination

Turner's paintings of mountains evolved from sketches and notes
jotted down in hundreds of sketchbooks during the course of his many
travels. This is a good place for any painter to begin. Your studies can
be as simple or complex as you wish. The key is to make plenty of them.
Your experiences and sketches can then form the basis for paintings.

Below:
J.M.W. Turner
Ebernburg from the Valley of the Alsenz 1844
from *Rheinfelden* sketchbook
Pencil, watercolour and pen on paper
22.9 x 32.6
Tate

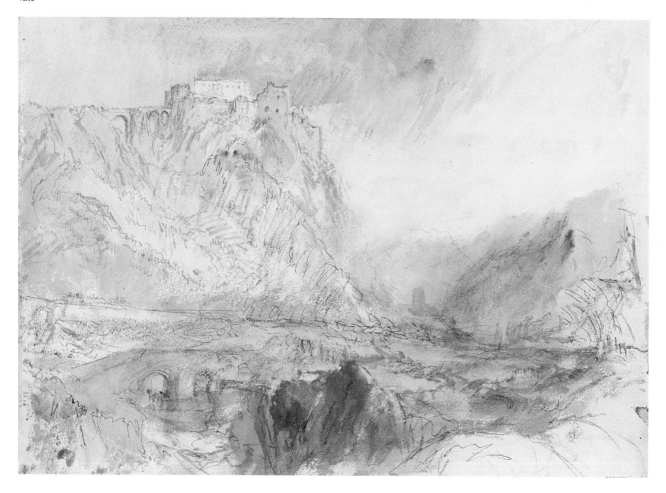

Simple sketches in pencil and wash

In the absence of nearby mountains, take every opportunity to record images you see of them around you – from television, photographs, your imagination and, of course, on location. The sketches used in the next two exercises are from my own visit to the Swiss Alps.

1. Use your pencil as Turner did, to experience and record your observations.

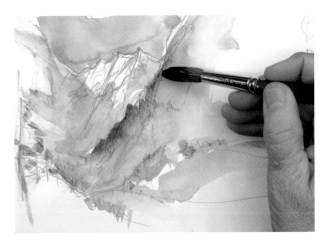

2. Even brief sketches can record the setting, scale, shape and shadowing of massive land formations and these can be washed in later or on location.

Studio colour studies onto wet paper

Using my sketchbooks as a starting point, this study was made from the imagination in the studio. It makes use of a Turner approach, beginning with the palest warm colour followed by deeper passages of a warmer colour and finally the introduction of a cool passage that balances the composition. The specific colours do not matter; just the warm/cool relationship and tonal contrast.

1. Wet your paper and smooth it onto your painting board. Starting with the palest yellow, lay in the sky using a large pointed sable brush. Follow this with a slightly deeper toning of colour to suggest clouds rising over mountains.

2. Then, working into this wet surface, suggest the shape of distant ridges rising out of a misty valley suffused with morning sunlight. Allow it to dry a little so that the closest ridge will have a slightly sharper edge, and then brush that in with a little blue.

Painting Mountains 2

Tony Smibert

Colour wash over pencil drawing

Turner often made pencil sketches on the spot, and added colour from his imagination at a later stage. This study follows that principle and allows you to experiment with different ways of creating texture with the brush. Never be afraid to over-work or under-work your study pieces. This is where you learn what can be done (and undone) while exploring the possible ways in which you might later develop ideas into finished art. Don't worry about the notion of copying a specific Turner painting, but let him be your guide to an approach that is both structured and creative. Don't settle for one study. Turner didn't!

Below:
J.M.W. Turner
Mont Blanc and the Glacier des Bossons from above Chamonix; Evening 1836
Pencil and watercolour on paper
25.6 x 28
Tate

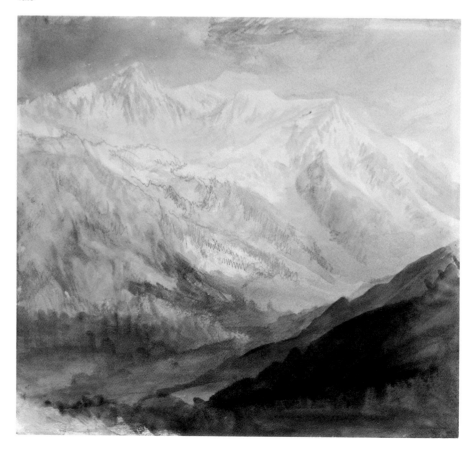

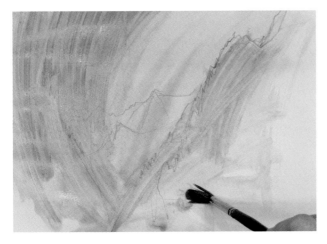

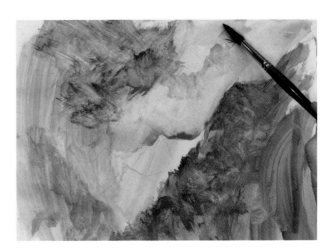

1. Start with a pencil sketch of a mountainous view. Then dash in the golden light of evening with yellow ochre using the sweep of your imitation sable brush to curve the wash over the valley below. I painted this directly into a sketchbook as Turner himself often did; you can see the page rippling because the paper is not stretched.

2. Loosely brush in the area above the ridge and let your brushmarks suggest blue sky glimpsed through breaks in the cloud. Using burnt umber, lay the mid-toned slope in the foreground by dragging the side of your brush over the surface to suggest scree scattered around the slopes among trees and other debris.

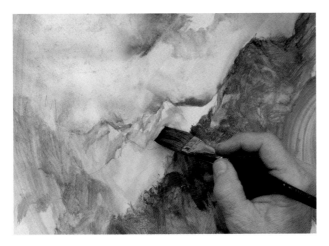

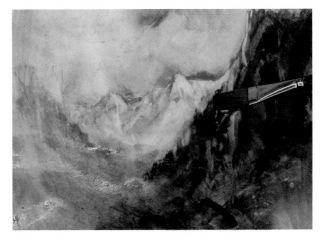

3. Use the crisp edge of a flat sable or nylon wash brush to lay in shadows along the faces of the distant peaks.

4. Rocks can be picked out and painted around, or shadowed to give them form. Highlights can be lifted by wetting and then removing pigment with a dry tissue or blotter. You can also take overly fussy detail away by washing out. Experiment with different finishes – for example, lightly shadowing the valley with a reversed gradation wash of cobalt blue.

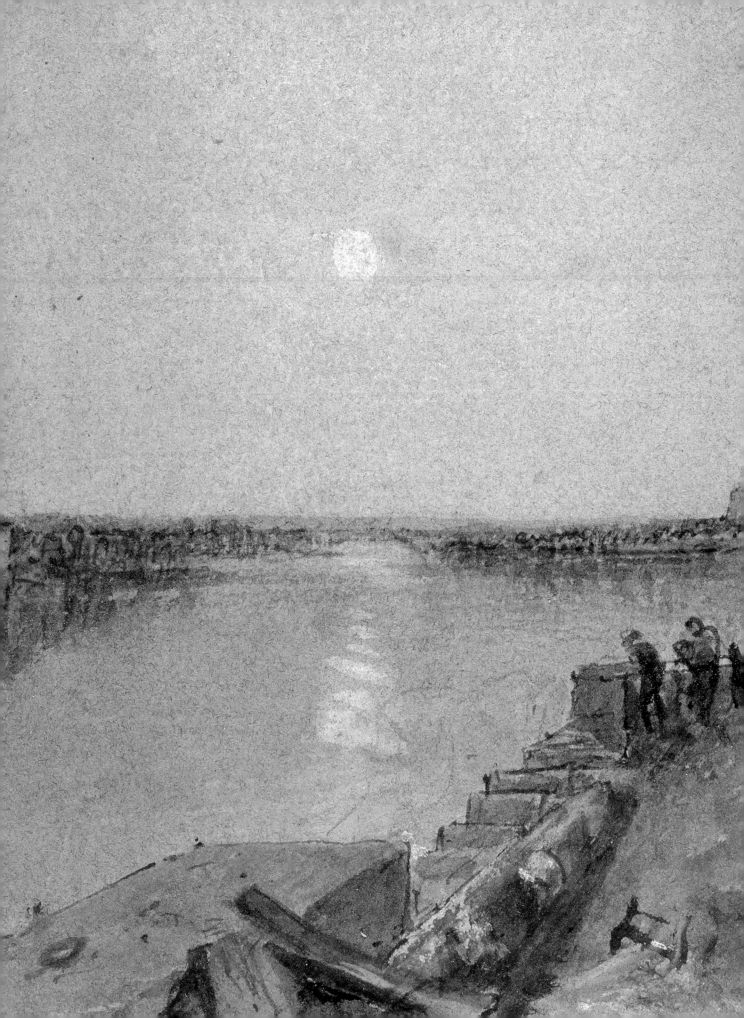

Sunrise and Sunset

According to Ruskin, towards the end of his life, Turner remarked: 'The Sun is God.' Whether this comment was intended to be understood literally, as a personal creed, or metaphorically is not clear. It is, nonetheless, an apt summation of the devotion Turner had paid the sun in so many of his paintings and watercolours.

Few painters before or since have so consistently placed the sun at the heart of their images, to the extent that it, and the qualities of its light, become as much the subject of Turner's pictures as the scenes depicted. He took his cue from the celebrated views of imagined seaports by the seventeenth-century French artist Claude Lorrain, in which the viewer's eye is expertly drawn away from the foreground figures towards the rising or setting sun through a subtly underlying – and inescapable – perspective grid. As well as absorbing from Claude just how potent the emphasis on a natural effect could be, Turner assimilated the idea that lighting effects could acquire moral or symbolic meanings. For example, the light of dawn had traditionally been understood as that of hope and promise, while that of sunset could be a shorthand means of indicating decadence or the approach of death. Turner used exactly this formula in his evocations of the rise and fall of ancient Carthage for two of his most celebrated paintings (The National Gallery and Tate, respectively).

By the late 1810s Turner had developed a simple but very effective way of laying down broad washes of watercolour that replicated the gradations of light across the sky, sometimes incorporating the sun itself in his designs (see p.45). He covered sheet after sheet with studies of this kind, experimenting with different tones, or paper types, rather like an actor placing different emphases on his words as he rehearses. These private studies helped to equip Turner with an elementary visual 'vocabulary' that he was able to apply in more elaborate landscapes, such as the hundreds of watercolours he painted of Britain in the 1820s and 1830s.

Even during his lifetime, there was a tendency to associate Turner most closely with sunsets, despite his protests that he actually preferred studying the more gradual effect of a strengthening sunrise. Undoubtedly the chief celebrant of Turner's sunsets was Ruskin, whose partiality for what he believed was their inherent pessimism, sometimes seduced him into misinterpreting dawn scenes as evocations of twilight, as was the case for several of the Loire views (left). That series was painted on the small sheets of

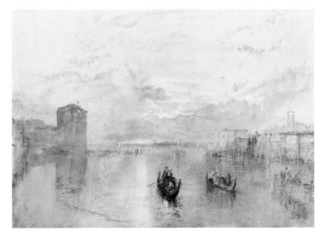

blue paper that Turner repeatedly employed for well over a decade, and on which he made some of his most vibrant studies, including the atmospheric views recreated on pp.94–7 and 116–19.

In recent years there have been attempts to account for the vivid colours Turner adopted in his sunsets by relating them to the dust in the atmosphere following the eruption of Mount Tambora, on the island of Sumbawa in Indonesia, in 1815. These dense clouds of volcanic matter had a dramatic impact on the earth's climate and atmospheric phenomena, resulting in cooler, wetter weather during the following years. While Turner was certainly alert to such changes, having paddled his way across Yorkshire in 1816, it is likely that the majority of his watercolour sketches of sunrise or sunset were actually made in his studio, based on his recollections, and so are unreliable as evidence of what he witnessed directly. More reliable are the notes in his sketchbooks, but what is remarkable about them is that they indicate he often found it most efficient to record an effect, or the course of the sun's movements, in pencil only, annotating his image with abbreviated colour indications. IW

How to Paint
The Scarlet Sunset

Mike Chaplin

This small densely painted study needs bravura in laying the first yellow and red washes. Let your brush dance over the paper and don't be disheartened if the first washes look brash. The image is tempered when the blues are added.

**Colours used
in this exercise:**

Cadmium yellow deep

Scarlet lake

Burnt umber

Cobalt blue

Ivory black

Chrome yellow

Below:
J.M.W. Turner
The Scarlet Sunset c.1830–40
Watercolour and gouache on blue paper
13.4 x 18.9
Tate

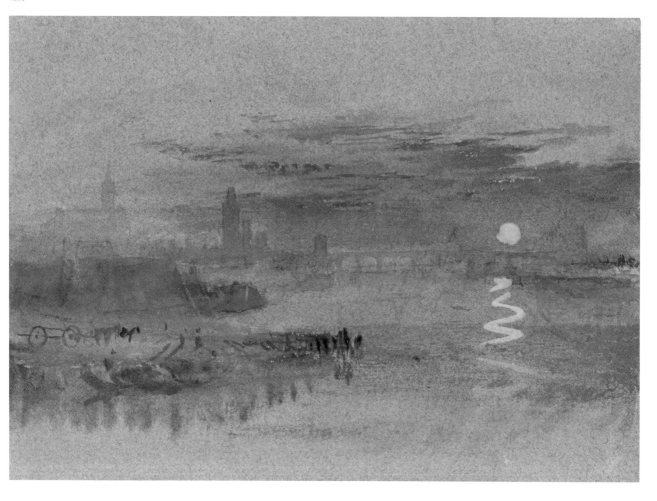

1. Across the top of your sheet of blue paper, wash in an expanse of cadmium yellow deep, vigorously blending into this an area of scarlet lake with a large pointed sable brush. While your brush is charged with the red colour, brush it over the foreground to create the reflection of the sunset.

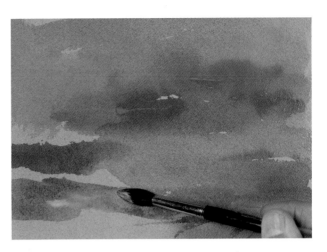

2. Intensify the effect by adding bold slashes of pure scarlet lake. Use washes of burnt umber to begin creating the river bank.

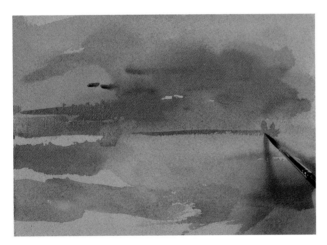

3. While your brush is charged with burnt umber, add touches in the sky for darkening clouds. Then, using a finer brush, draw in the span of the bridge with a sweeping stroke of cobalt blue mixed with ivory black.

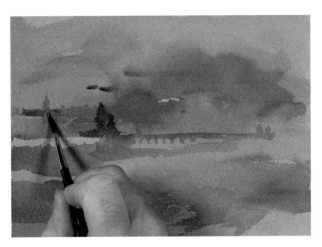

4. Now add more detail to the bridge and horizon, using a fainter wash for the distant buildings.

exercise continues overleaf

117

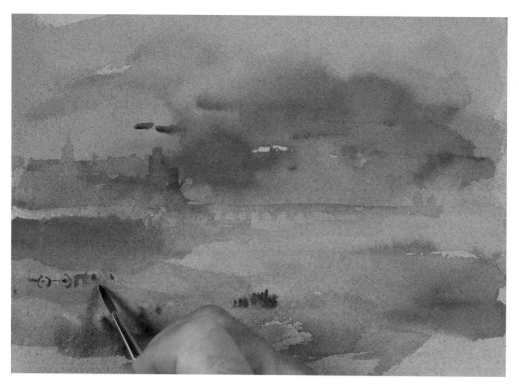

5. The dark group of figures, as well as the horse and cart, can be created with a fine pointed brush using varying strengths of burnt umber. The shadows of these features can be created in the same way.

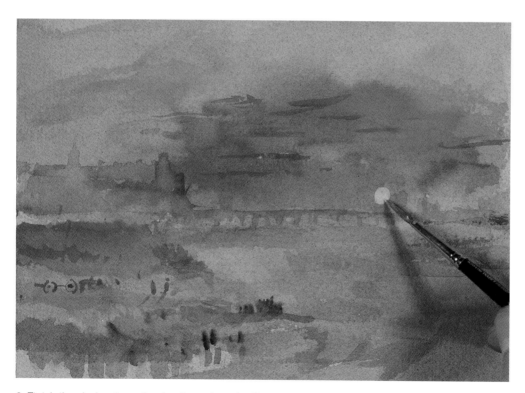

6. Finish the sky by strengthening the reds and yellows. After this put in a touch of chrome yellow for the setting sun.

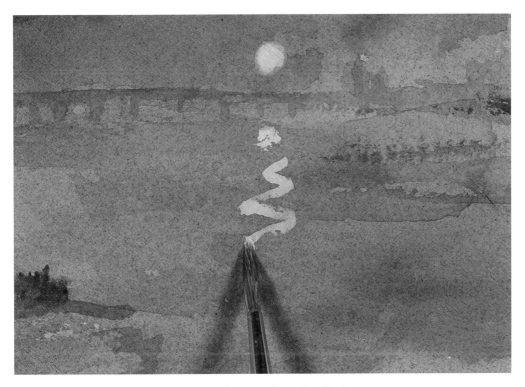

7. Continue the effect below the bridge by lightly tracing the sun's reflection in a calligraphic flourish.

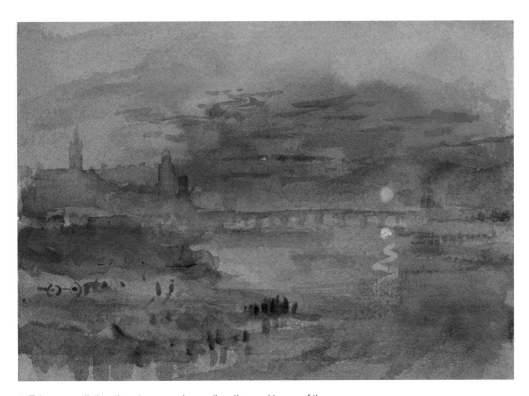

8. Taken overall, the vibrant warm colours allow the cool tones of the paper to come through, giving a subtle sense of distance and space.

Painting Sunlight 1

Tony Smibert

Painting a cloudy sunset

Turner's knowledge of how to paint the sun came from years of practical observation, sketching, experimenting and painting. Many of his most evocative studies of it were painted very rapidly, using few marks and a simple watercolour technique. The first thing to note is that it is not always necessary to show the orb of the sun in order to portray it.

Below:
J.M.W. Turner
Crimson Sunset c.1825
Watercolour and gouache on paper
24.3 x 34
Tate

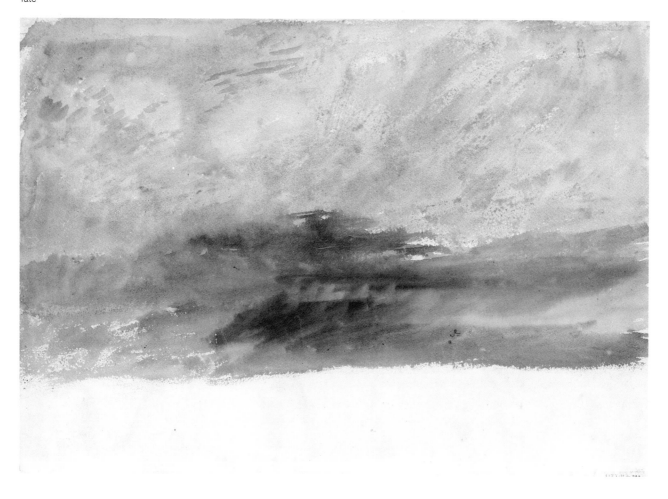

1. Here is a very simple exercise to get you started with a Turner approach. Imagine you have just watched the sun setting over the ocean. Start by laying an area of yellow ochre wash using the side of a pointed sable or imitation sable brush. Then charge your brush with a little red and use this to establish warm clouds and the surface of the ocean. Finally, load with a stronger wash of the red and use only a few strokes to dash in the shapes of nearby clouds glowing heavily above where the sun has just set.

2. If you want to show the sun's orb, once again start with a basic wash of yellow ochre, warmed with a deeper warm colour – I used light red. Remember to leave the central area unpainted. Then outline the circle of the sun faintly, and gradate a wash around it using the original yellow, so that the colour fades away as it gets further from the orb.

3. Using the side of a dampened brush, pick up some warm colour from your palette. Then with a dry-brush technique (using the side of your brush lightly dragged across the paper) introduce some clouds.

4. Finally, in the upper reaches of the sky, add some patches of blue sky seen beyond the glow. Once it's dry, erase any pencil lines you may have used for the sun.

Painting Sunlight 2

Tony Smibert

Sun rising or setting over calm water

If you start with relatively simple compositions, you will soon have
a system that can be applied in a range of ways: for example, by
combining this approach with the previous demonstration, the sun
might be painted and then concealed behind dramatic clouds. You
can use your own photographs as reference so that, like Turner, you
draw inspiration from places you've visited and things you've seen.

Below:
Sunset on the Nile

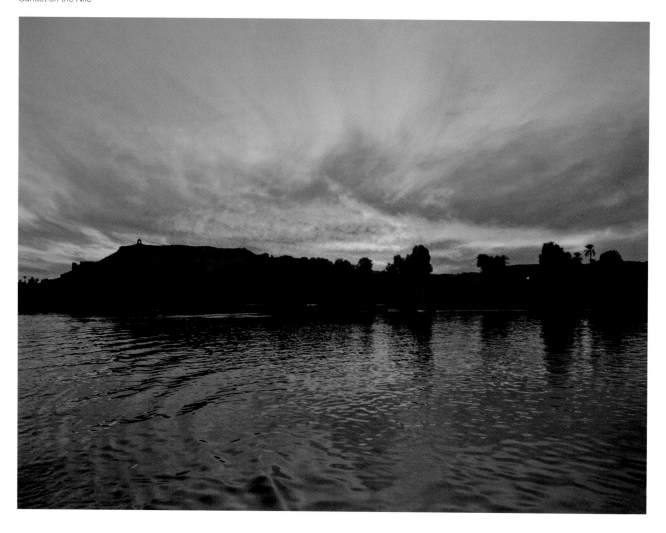

1. Wet both sides of your paper and smooth it onto your painting surface. Working on this wet surface, lay a pale, variegated wash of yellow strengthened with Indian red. This establishes the sky, a cloud mass in the centre and the ocean in the foreground – with the water reflecting the colour and tone of both. Before this dries, establish the distant horizon, lost in glowing mist, with a single sweep of your brush and a little more of the Indian red.

2. Before this dries, wrap the tip of your finger with a piece of tissue and press it into the wet surface where you want the sun to be. This will lift the pigment leaving a soft-edged white shape that represents the sun. Quickly wrap your finger again in a clean tissue and wipe out the glowing reflection below the sun.

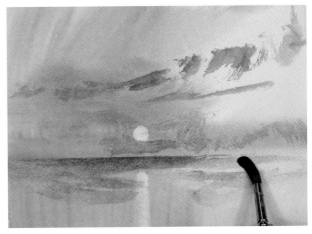

3. When the various washes have dried, use the moistened brush to pick up a little of the Indian red or any colour or toning you believe will create the effect you want, and use the side of the brush to suggest the broken shapes of clouds receding into the mist.

4. Finally, introduce a cool blue into the ocean with subtle passes of the brush. Looking back over these stages you may feel that each one felt relatively complete in itself, and that the painting could have stopped at any point. This is part of the joy of watercolour, in which a mastery of detail is not always essential in portraying nature.

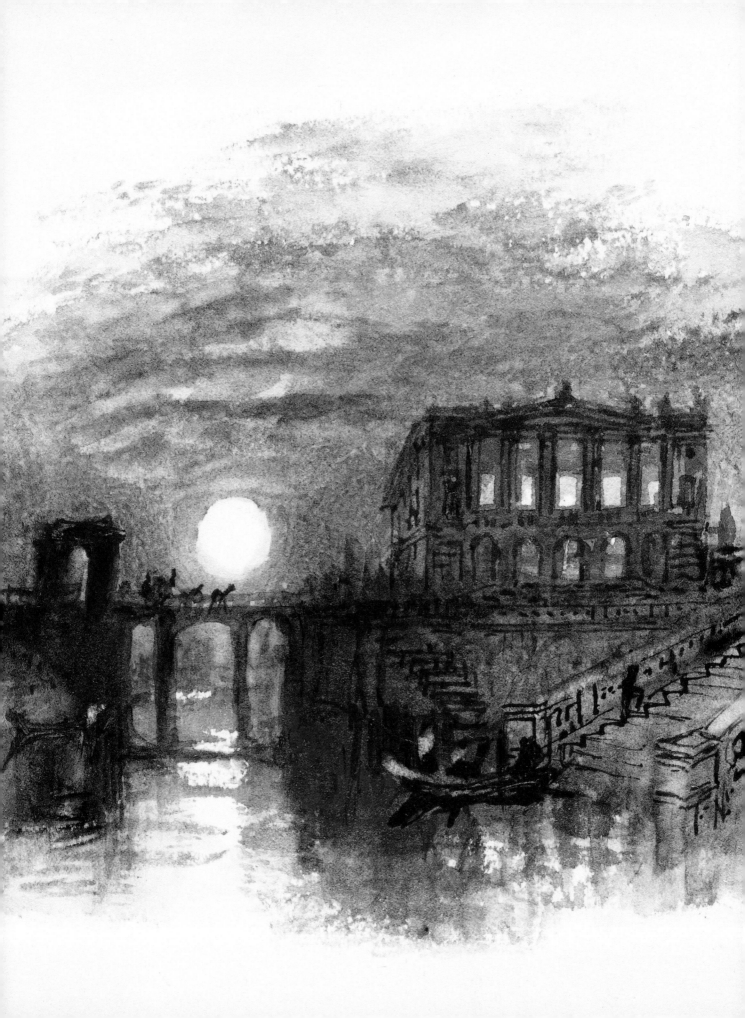

Moonlight

Turner was one of the first artists to repeatedly paint a subject at different times of the day, charting the transient effects of changing light upon a particular motif. He is remembered as the great chronicler of sunrise and sunset, but his obsession was not confined to the daytime.

Despite the fact that he allegedly found painting moonlight particularly troublesome, some of Turner's most evocative paintings are nocturnal scenes featuring silvery lunar effects. Indeed, the first two oil paintings he ever exhibited were both moonlit vistas: *Fishermen at Sea* 1796 (Tate) and *Moonlight*, a *Study at Millbank* 1797 (Tate). It was typical of his rigour and determination that at this early point in his career he deliberately set out to master an effect that he found so technically demanding.

During the nineteenth century, moonlight was much more than a purely natural phenomenon. Like many artists and writers during the Romantic period, Turner explored the emotive and symbolic impact of its transformative effects. His works can be seen as coinciding with, and contributing to, a wider cultural movement celebrating the emotional resonance of the night, most famously represented by Beethoven's 'Moonlight Sonata' (1801), or the coining of the phrase 'Nocturne' to describe the musical and visual compositions of John Field, Frédéric Chopin and James McNeill Whistler respectively. Many of Turner's nightscapes contain poetical allusions, or are direct illustrations for contemporary writers, such as Walter Scott, Samuel Rogers and Lord Byron. The after-dark setting for the vignette watercolour *A Villa, Moonlight (A Villa on the Night of a Festa di Ballo), for Rogers's 'Italy', 1830* (left), for example, lends an exotic aura of enchantment and mystery to the Genoese scene described in the poem by Samuel Rogers.

Part of the challenge of depicting moonlight in watercolour arises from the unique approach required for the creation of areas of white. The properties of the medium call for different strategies, and whites must be added, removed or preserved, but never simply applied like other colours. Turner varied his methods accordingly. At times he conjured the impression of moonshine by reserving or lifting paint on white paper, for example in *Shields,*

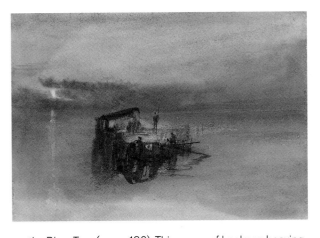

on the River Tyne (see p.130). This scene of keelmen heaving coals was engraved and published in 1823 as part of a series of prints called *The Rivers of England*. The velvety midnight sky and eerie white luminescence was particularly effective when translated into black and white mezzotint. However, some of the artist's most effective night-time landscapes were those that employed brilliant opaque gouache (or bodycolour) on blue paper. Perhaps the most striking of these is *St-Denis* (see p.126) from the topographical series entitled *Turner's Annual Tour: The Seine 1835 Watercolours*. In this view, a full moon surrounded by a yellow aureole of light illuminates the scurrying clouds, and Turner has also picked out twinkling stars with small pinpoints of white pigment. There is a cold density to the light, which contrasts with the ghostly silhouette of the cathedral and pale reflection on the river below. The inclusion of subtle maculate shadows on the face of the moon is evidence that Turner could be scientifically accurate, but only when it suited his aesthetic purposes. NM

How to Paint
St-Denis

Mike Chaplin

Blue paper was one of Turner's favourite surfaces for painting with watercolour and the addition of opaque white (or gouache) makes a striking moonlit scene. If you are unable to find a suitable blue paper then try colouring a heavyweight paper with a blue wash by brushing or dipping the sheet.

Below:
J.M.W. Turner
St-Denis c.1833
from *Turner's Annual Tour:*
The Seine 1835 Watercolours
Gouache and watercolour on blue paper
14 x 19.2
Tate

Colours used in this exercise:

Ultramarine

Ivory black

Burnt sienna

Titanium white

Cobalt blue

Cadmium red

Lemon yellow

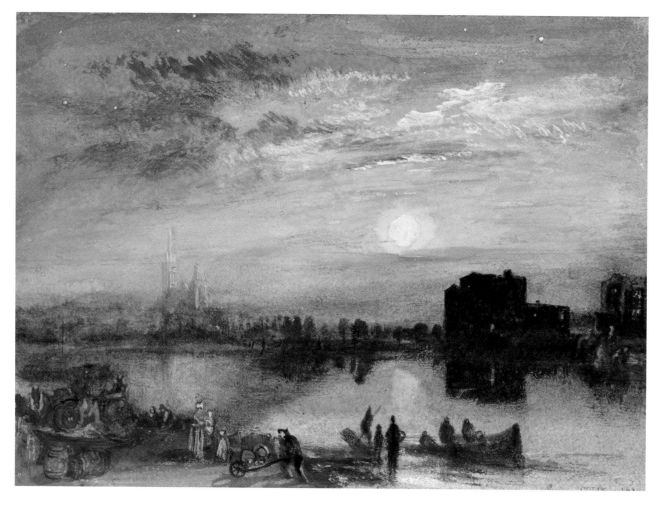

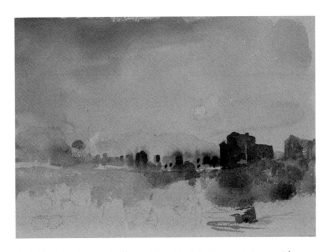

1. Using a flat sable wash brush, introduce a strong ultramarine wash at the top left-hand side of the paper and then reduce with water to produce a gradated tone towards the bottom right. Leave a small circle of the paper blank at the point where the moon will be.

2. Add dark blue marks (by adding black to the wet sky wash) to show distant, soft-edged trees. Allow the wash to dry before continuing with hard-edged accents for the nearer trees and buildings.

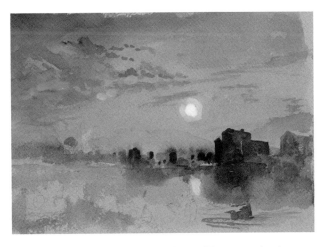

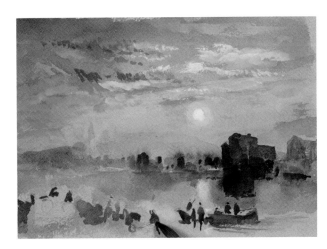

3. Draw in the first clouds and apply initial foreground colour in burnt sienna. The moon and its reflection should first be painted as a wash of reduced opaque white and then defined with pure opaque paint.

4. Further painting with dark and light colours in the sky establishes tonal depth. Lightly brush in the foreground figures using a large pointed sable brush.

exercise continues overleaf

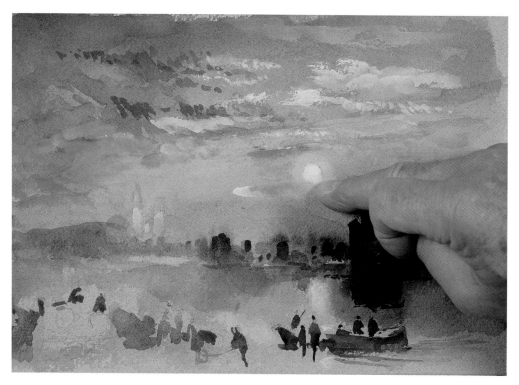

5. With a smear of cadmium red (dirty from the palette), paint in the warm cloud under the moon and soften with a finger.

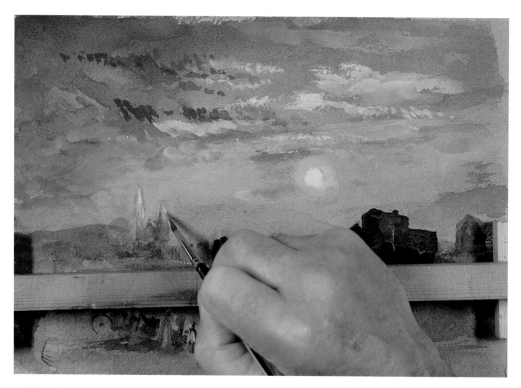

6. With a fine brush, start to define the character of the figures using white highlights. You can use a simple wooden rest when you add details to the cathedral to avoid the danger of smudging the foreground figures.

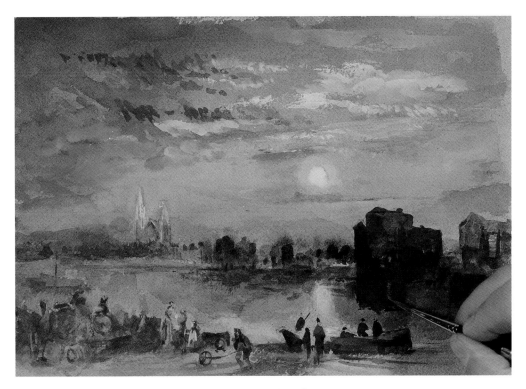

7. The single red light and its reflection are added, establishing the middle distance and enhancing the coolness of the moonlight.

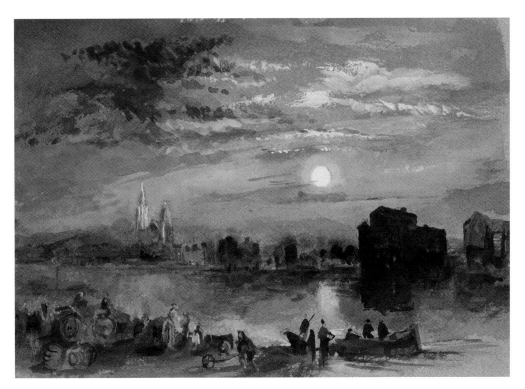

8. As a last touch, add final dark tones and highlights of colour among the figures and around the boat in the foreground. Thin lines of cloud edging in front of the moon complete the painting.

Painting Moonlight

Tony Smibert

Moon and moonlight

The moon in *Shields, on the River Tyne* (below) was not painted onto the sky, but removed from it by a very straightforward method. The following study repeats the process using a simpler composition and subject.
It follows three stages: first, the moonlit sky; second, the landscape setting; and finally, the human element that completes the story. As you work, you may at various points feel that your picture seems complete and not want to add further detail. If that happens, consider stopping and then painting further versions, experimenting with colour, approach and subject.

Below:
J.M.W. Turner
Shields, on the River Tyne 1823
Watercolour on paper
15.4 x 21.6
Tate

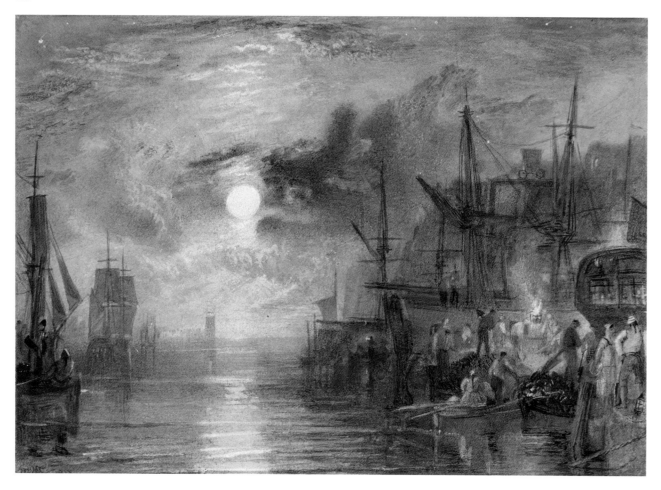

1. First tape a dry sheet of quite heavy paper to a board and wet the surface with clean water. Using a large flat wash brush, flood it with washes of Prussian blue, with Indian red blended here and there to add some warmth.

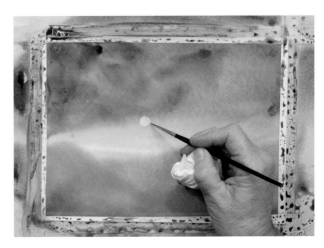

2. Allow that to dry completely before proceeding to the next stage. Lightly draw in the outline of the moon in pencil, then wet a fine brush and paint within the circle using clean water to soften the pigment. Immediately lift the colour from within the circle using an absorbent material (tissue is perfect) and, if necessary, wipe it hard with another clean tissue to reveal the white paper.

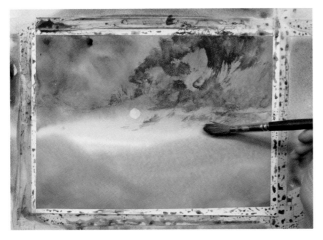

3. Dampen your brush and use it to pick up a little Prussian blue wash from your palette. Sweep this in from the upper reaches of the sky to lead the eye so that the moon is seen to be the primary subject in the composition. These dry-brushed clouds will contrast with the softness of the previous wash.

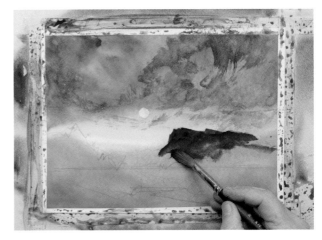

4. Use a pencil to sketch in the outline of mountains on the other side of a lake. Then wash them in with Prussian blue, gradating the paint away from the peak nearest to the moon.

exercise continues overleaf

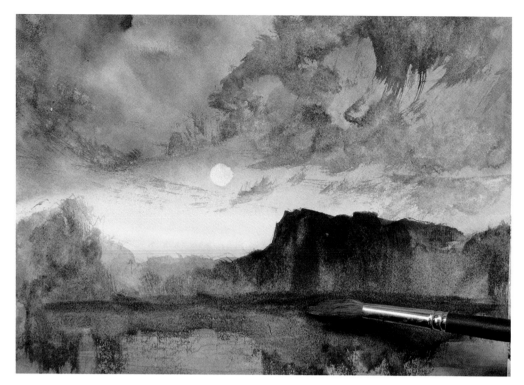

5. Continue the wash down into the lake so that it suggests the dark reflection of the range of mountains, and then gently lift some of the wash while it is still wet using a dry tissue. Consider this as an experiment that, if successful, will bring light and life back into the reflection. You may also find that a horizontal sweep of darker wash through this shadowed reflection will help to suggest the surface of the lake.

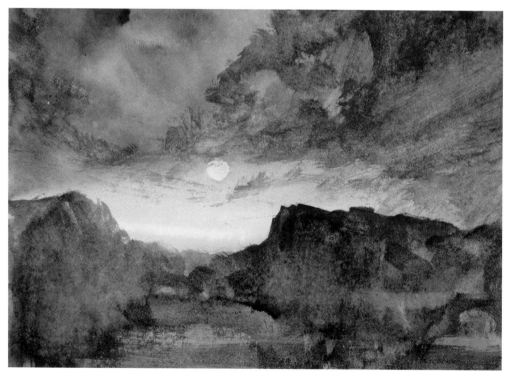

6. Unhappy with the result, I immediately laid a passage of diluted burnt umber into areas of the shadow and wiped away much of the darkness. This introduced warmth and vitality into an area that might otherwise have been flat and dull.

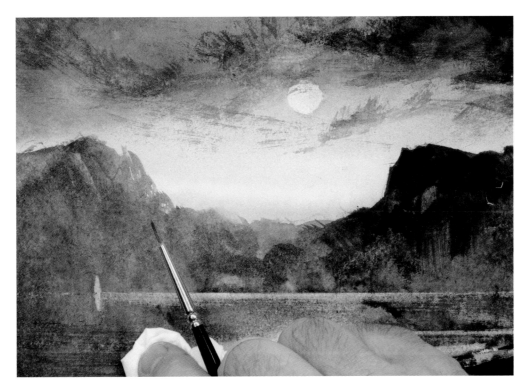

7. The study could finish here or might be taken further with the addition of compositional devices such as a white sail reflected in the surface of the lake. This is painted using the same technique as for the moon, by wetting and lifting with an absorbent material such as a tissue or blotter.

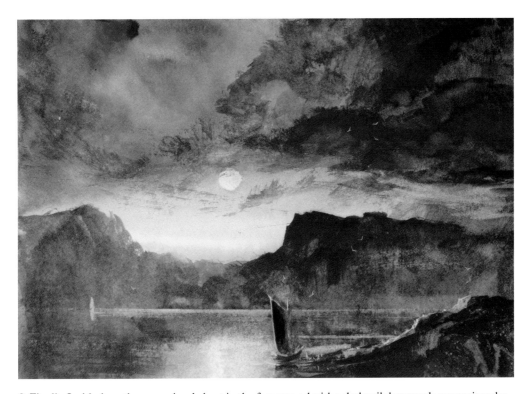

8. Finally, I added another very simple boat in the foreground with a dark sail that stands out against the moonlight reflected on the lake. The challenge lies in painting the sky and surrounding scenery so that light and dark complement each other throughout the composition and the nocturnal landscape seems to be bathed in light. A painting like this might be seen as complete in itself, or viewed as an opportunity to experiment with ways to add details. Here, for example, bodycolour was used to introduce birds circling in the sky, and light catching on objects in the foreground.

Chronology

1775
23 April: likely date of birth of Joseph Mallord William Turner, 21 Maiden Lane, Covent Garden, London. Son of William, a barber and wig-maker, and Mary (née Marshall). Christened at St Paul's Church, Covent Garden.

1785
Hand colours engravings from Boswell's *Picturesque Views of the Antiquities of England and Wales* while staying with his maternal uncle (a butcher) in Brentford, Middlesex.

1786
Stays at Margate and makes his earliest surviving drawings.

1789
Works as a draughtsman for architect Thomas Hardwick (1752–1829). Then employed by Thomas Malton, Jr. (1748–1804).
11 December: admitted as a student of the Royal Academy Schools after one term's probation.

1790
Exhibits first work at the Royal Academy (RA), the watercolour *The Archbishop's Palace, Lambeth* (Indianapolis Museum of Art).

1791
September: makes his first tour of the West Country, including Malmesbury, Bath and Bristol.

1792
June: begins his studies in the life class of the RA.
Summer: makes his first tour of southern Wales.

1793
27 March: awarded the 'Greater Silver Pallet' by the Royal Society of Arts for landscape drawing.
Summer: tours along Welsh borders, including Hereford and Tintern.
Autumn: tours of Kent and Sussex.

1794
The five watercolours he exhibits at the RA lead to the first reviews of Turner's drawings.
Starts to work regularly at the home of Dr Thomas Monro (1759–1833), collaborating with Thomas Girtin (1775–1802) on copies of works by John Robert Cozens (1752–97) and other artists.
Begins to take pupils for drawing lessons.
Summer: first tour to the Midland counties of England, with a brief journey into northern Wales to make watercolours for one of his first engraving commissions for the *Copper-Plate Magazine*.

1795
Summer: tours southern Wales, followed by a journey to the Isle of Wight.

1796
Exhibits his first oil painting at the RA, *Fishermen at Sea* (Tate), along with ten watercolours.

1797
Summer: first extensive tour of the north of England, including the Scottish borders and the Lake District. Visits Harewood House to execute commissions from Edward Lascelles, Jr. (1764–1814).

1798
April: sketching tour of Kent.
Summer: from Bristol, makes an extensive tour through south and north Wales; visits the birthplace of Richard Wilson (1713–82).
November: decides to give no more drawing lessons.

1799
April: Lord Elgin seeks to secure his services as draughtsman on his forthcoming trip to Greece, but Turner rejects his terms.
August – September: visits Fonthill, Wiltshire to gather material for a commission from William Beckford.
October: visits the home of his friend W.F. Wells at Knockholt in Kent, where he makes his first attempt at producing oil studies from nature.
4 November: elected an Associate of the Royal Academy.
November/December: moves to 64 Harley Street, London, sharing a studio with the marine painter, J.T. Serres (1759–1825).
Begins his affair with Sarah Danby (1760/66–1861).

1800
27 December: his mother admitted to the Bethlem Hospital for the insane, where Dr Monro was the physician.

1801
June – August: first tour of Scotland; returns through the Lake District.
Probable date of birth of Evelina, Turner's eldest daughter with Sarah Danby.

1802
12 February: elected a full member of the Royal Academy. Signature revised from 'W. Turner' to 'J.M.W. Turner'.
15 July – mid-October: first continental tour: travels with Newbey Lowson, an amateur artist, to Switzerland, as well as making an extended stay in Paris to see the looted treasures hoarded in the Louvre.

1803
Criticised by Sir George Beaumont and other Academicians for the 'lack of finish' in his works.
Prepares his own gallery at 64 Harley Street (at the corner with Queen Anne Street).

1804

15 April: death of Turner's mother.
18 April: first display at his newly completed gallery includes between twenty and thirty of his own works.

1805

Exhibits *The Shipwreck* (Tate) at his own gallery, which becomes the first of his oil paintings to be engraved (supported by 130 subscribers).
May: rents Sion Ferry House at Isleworth. Sketches from a boat on the Thames.
December: sees Nelson's flagship, the *Victory*, after it returns from the Battle of Trafalgar.

1806

Shows two oil paintings at the first exhibition of the British Institution, a rival body to the RA, run by aristocrats rather than artists.
Summer: stays with W.F. Wells at Knockholt, Kent; the two devise the series of prints that becomes the *Liber Studiorum*.
Winter: takes a house near that of P.J. de Loutherbourg at 6 West End, Hammersmith with a garden on the riverside; the summerhouse serves as his studio.

1807

The display at his own gallery includes some of his recent Thames landscapes, which are denounced as 'crude blotches' by Benjamin West (1738–1820). Buys a plot of land at Twickenham, intending to build his own home.
11 June: first part of the *Liber Studiorum* published.
2 November: elected Professor of Perspective at the Royal Academy.
First review of Turner's work in France appears in the *Magazin Encyclopédique*.

1808

Summer: visits Tabley, Cheshire, the home of Sir John Leicester (1762–1827). Also stays for the first time at Farnley Hall in Yorkshire, the home of Walter Fawkes (1769–1825), where he is a frequent visitor until Fawkes's death.

1809

Summer: stays at Petworth House, Sussex, the home of the third Earl of Egremont (1751–1837), to make drawings for a commissioned view of the house. Subsequently visits the Earl's Cumbrian property, Cockermouth Castle, to pursue another commission.

1810

2 May: changes his address to 47 Queen Anne Street West.
Visits Jack Fuller (1757–1834), Member of Parliament for East Sussex, who commissions a series of watercolours of his home at Rosehill Park, near Hastings.

1811

January – February: delivers the first series of six lectures as Professor of Perspective.
July – September: tours Dorset, Devon, Cornwall and Somerset to make watercolours for *Picturesque Views on the Southern Coast of England*, published by William Bernard Cooke (1778–1855).
Likely year of birth of Georgiana, Turner's second daughter with Sarah Danby.

1812

Appends the first extract from his manuscript poem, 'The Fallacies of Hope', to the title of his painting *Snow Storm: Hannibal and his army crossing the Alps* in the RA exhibition catalogue (Tate).
Designs and begins building Sandycombe Lodge, his suburban villa, at Twickenham.

1813

May: attends RA dinner and sits next to Constable, who comments on Turner's 'wonderful range of mind'.
Summer: visits Plymouth in Devon, where his friends Charles Eastlake, Cyrus Redding and Ambrose Johns encourage him to make oil sketches from nature.

1814

First four parts of *Picturesque Views on the Southern Coast of England* appear during the year.

1815

The sculptor Antonio Canova (1757–1822) describes Turner as 'un grand génie' after a visit to his gallery.
Summer: possibly visits the south coast, including Hastings, to make drawings for *Views in Sussex*.

1816

Elected Chairman of Directors and Treasurer of the Artists' General Benevolent Fund.
July – September: tours Yorkshire and north of England, collecting material for Whitaker's *History of Richmondshire*.

1817

10 August – 15 September: visits Belgium (including the battlefield of Waterloo), Holland and the Rhineland. Produces a group of fifty watercolours, which are bought that autumn by Walter Fawkes.

1818

October – November: visits Edinburgh to begin work on the illustrations for *The Provincial Antiquities of Scotland* by Walter Scott (1771–1832).
November: stays at Farnley, where he completes a number of watercolour views of the house, as well as the watercolour *A First-Rate Taking in Stores*.

1819

January: last part of the *Liber Studiorum* published.
March: eight of his oil paintings shown in the gallery of Sir John Leicester's London home on Hill Street.
May – June: more than sixty of his watercolours exhibited at Fawkes's London home at Grosvenor Place. This retrospective is warmly greeted by the press.
August – February 1820: first trip to Italy, where he visits Venice, Rome, Naples and Florence.
24 November: elected an honorary member of the Roman Academy of St Luke's through Canova's sponsorship.

1820

At the Royal Academy, his experience of Italy is encapsulated in a painting marking the tercentenary of Raphael's death: *Rome from the Vatican* (Tate).
June: Inherits property in Wapping, East London, and converts it into the Ship and Bladebone public house.

1821

No exhibits this year at the Royal Academy, while Turner enlarges his own gallery.
Summer: visits Paris and northern France.

1822

Produces designs for an engraving project called *Marine Views*.
April: first display at Turner's new gallery on Queen Anne Street West includes several unsold, earlier works.
August: travels to Edinburgh with the intention of recording George IV's state ceremonial visit in a series of paintings.

1823

Publication of the first plates of *The Rivers of England*.
Begins work on a commission from George IV to paint *The Battle of Trafalgar* for St James's Palace; his largest canvas, and his only Royal commission (National Maritime Museum).

1824

Summer: Starts to work on the *Picturesque Views in England and Wales*, a project which occupies much of his time over the next fourteen years.
August – September: first tour of the Rivers Meuse and Mosel, also encompasses Luxembourg and northern France.
December: last visit to Farnley Hall, the home of Walter Fawkes.

1825

August: tour of Holland.
The first four watercolours for the *Picturesque Views of England and Wales* are completed.
25 October: death of Walter Fawkes.

1826

Sells Sandycombe Lodge.
April: first of the *Ports of England* mezzotints published.
August: visits Normandy, Brittany and the Loire. Commissioned by Samuel Rogers (1763–1855) to illustrate the poem *Italy*.

1827

7 July: at the sale of the Tabley collection (acquired by Sir John Leicester) buys back *Sun Rising through Vapour* and another of his own paintings.
July – August: stays at East Cowes Castle on the Isle of Wight, the home of the architect John Nash (1752–1835). Returns via Petworth House, becoming a regular visitor there until 1837.

1828

January: last series of his six perspective lectures.
Summer: at Petworth, at work on the landscapes for the Carved Room.
August – February 1829: second visit to Rome; travelling there via Paris, Lyons, Avignon and Florence.
18 December: causes outrage with the display of three of his most recent paintings at the Palazzo Trulli, via del Quirinale, Rome.

1829

February: returns to London via Turin, Mont Cenis and Mount Tarare.
June – July: the publisher Charles Heath (1785–1848) exhibits thirty-six of the *England and Wales* watercolours at the Egyptian Hall in Piccadilly. Many are acquired by Thomas Griffith, who later becomes Turner's agent.
August – September: travels to the Channel Islands, Normandy and Paris. Probably visits Eugene Delacroix (1798–1863) during his stay in Paris.
21 September: death of his father.
30 September: draws up his first will, a day after his father's funeral.
Begins to stay at Margate, in the house of Sophia Caroline Booth (1798–1875), overlooking the harbour.

1830

Publication of Rogers's *Italy*.
Exhibits *Funeral of Sir Thomas Lawrence: A Sketch from Memory* (Tate), the last watercolour he shows at the RA.
August – September: tour of the English Midlands, largely to gather material for the project *Picturesque Views in England and Wales*.

1831

July – September: tour of Scotland in search of material to illustrate Sir Walter Scott's *Poems*, during which trip he stays with Scott at Abbotsford.

1832

March: twelve of his illustrations of Scott's *Poems* exhibited at the Pall Mall galleries of Messrs Moon, Boys and Graves.
October: travels to France collecting material both for his views of the River Seine and for Scott's *Life of Napoleon*.

1833

First volume of *Turner's Annual Tour* published: *Wanderings by the Loire*.
Exhibits first views of Venice at the RA.
His publishers, Moon, Boys and Graves, stage another show of more than fifty of his recent *England and Wales* watercolours.
September: journey to Venice takes him through southern Germany and Austria.
October: pursues a court case against Charles Tilt, seeking to protect his right to oversee the dissemination of his images.

1834

Publication of Rogers's *Poems* and the first set of engraved views of the Seine.
Illustrations to Lord Byron exhibited at Colnaghi's.
September: travels to Scotland in relation to Robert Cadell's edition of the works of Sir Walter Scott.
16 October: witnesses the destruction by fire of the Houses of Parliament in London.

1835

Last volume of *Turner's Annual Tour* published, containing the second group of Seine views.
Summer: tour of Denmark, Prussia, Saxony, Bohemia and Bavaria enables him to study the galleries at Berlin and Dresden.

1836

Summer: tour of France, Switzerland and the Valle d'Aosta with H.A.J. Munro of Novar.
October: first contact between Turner and John Ruskin (1819–1900). Ruskin offers to defend Turner against the criticisms in *Blackwood's Magazine* but Turner dissuades him.

1837

11 November: death of Lord Egremont.
28 December: resigns as Professor of Perspective.
Publication of an edition of *The Poetical Works of Thomas Campbell* (1774–1844) with twenty illustrations by Turner.

1838

Last of the *England and Wales* plates published.

1839

Exhibits *The Fighting Temeraire, Tugged to her Last Berth to be Broken up, 1838* (National Gallery, London)
August: second tour of the Rivers Meuse and Mosel, also revisits Luxembourg.

1840

22 June: the first documented meeting of Turner and Ruskin at the house of Thomas Griffith at Herne Hill (they may also have met earlier in Oxford).
August – October: travels to Venice via Germany and western Austria, returning via Vienna, Coburg and Wurzburg.

1841

July – October: visits Switzerland.

1842

Creates his first group of specimen subjects of Swiss views from which finished watercolours were to be made on commission. Collects nine orders, but produces ten in all; the last as Thomas Griffith's fee.
August – October: a further tour of Switzerland, travels there via Belgium.

1843

A further six watercolours commissioned and completed from a proposed group of ten.
August – November: visits the Tyrol and north Italy.

1844

Exhibits *Rain, Steam and Speed – The Great Western Railway* (National Gallery, London).
August – October: last visit to Switzerland, from where he returns via Heidelberg and the Rhine.

1845

A further group of ten Swiss watercolours executed.
May: brief visit to Boulogne, exploring the coast at Ambleteuse and Wimereaux.
14 July: as the eldest Royal Academician, appointed Acting President during the illness of Sir Martin Archer Shee (1769–1850).
September – October: visits Dieppe and is entertained at Louis-Philippe's chateau at Eu. Invited by the Congress of European Art to contribute a painting to celebrate the opening of the Temple of Art and Industry in Munich. Turner's *Opening of the Walhalla* (Tate) is derided for the 'want of exactness of portraiture in the place represented'.

1846

Under the assumed name of Admiral Booth, he begins to live at 6 Davis Place, Cremorne New Road in Chelsea.

1847

Apparently makes frequent visits to the photographic studio of J.J.E. Mayall on Regent Street.

1848

No exhibits at the RA for the first year since 1824.
Employs Francis Sherell as his studio assistant.

1849

Declines a request from the Society of Arts for a retrospective exhibition of his works because of 'a peculiar inconvenience this year'.

1850

Exhibits his last four oil paintings at the RA.

1851

March: receives a copy of the first volume of Ruskin's *Stones of Venice*, with a dedication from the author.
May: attends the annual Academy dinner for the last time.
19 December: dies at his home in Chelsea aged 76. His body is buried in the crypt of St Paul's Cathedral on 30 December.

Glossary

Blending: The process of mixing two or more colours together to create a fully integrated effect; usually achieved on wet paper, or by mixing the colours very thoroughly with a wet brush.

Blotting: See **lifting-out**.

Bodycolour: An historical term for **gouache**.

Brilliance: A term relating to the brightness or reflectance of the paper surface.

Charging: The loading of the artist's brush with colour.

Chiaroscuro: The treatment of light and shade in painting (from the Italian words 'chiaro', meaning clear, and 'oscuro', meaning dark).

Cold-pressed: This refers to papers with a slightly rough texture. They preserve a greater sense of the process of painting than the smooth, even application achieved on **hot-pressed** papers.

Dry brush: See p.46.

Finish: The surface characteristics of a sheet of paper as a result of treatments like hot pressing, cold pressing, pack pressing, glazing, sizing, etc. Each of these affects the brilliance, texture and tooth of the paper.

Formation Used to describe the dispersion of fibres in a sheet of paper.
 Close formation: An even distribution of tightly bound fibres. A sheet with close formation will give uniform results during painting and can be repeatedly reworked.
 Cloudy formation: A spotty, irregular dispersion of fibres. A sheet with cloudy formation is more difficult to work, and might yield unpredictable results.

Gouache: A form of watercolour thickened and made opaque through the addition of lead white (in Turner's time) or zinc white. Prior to the commercial availability of ready-to-use gouaches, artists improvised their own versions, generally known as 'bodycolour'.

Granulation: The grainy or mottled appearance of visible, large, pigment particles within a diluted colour. It can be used to add texture to a painting, although some modern paints aim to minimise the effect.

Gum arabic: A type of water-soluble gum produced in the sap of acacia trees. Used to bind pigments in watercolour painting. See pp.24, 102.

Hot-pressed: The process of passing gelatine-sized paper through hot cylinders producing a smooth, reliable surface, ideal for very detailed work in watercolour.

Laid paper: Unlike the smooth textures of wove paper, laid paper retains the regular lines of the moulds on which it was made.

Lifting-out: A means of lightening, or introducing detailed highlights, to an existing area of applied paint. Achieved by removing wet watercolour paint with absorbent material, or a damp brush. See pp.48, 131–3.

Masking fluid: Products are now available commercially to enable artists to protect areas of paper for subsequent development. See **stopping-out**.

Rattle: A combination of several properties including the stiffness and density contribute to the sound that a sheet makes when it is shaken. The rattle is a good gauge of the internal strength of the sheet of paper.

Scraping-out/scratching-out: A means of introducing a highlight to an area of painted paper by scratching away to reveal the original surface underneath. Turner apparently kept his thumbnail long specifically for this purpose.

Scumble: A method of layering a second colour over an existing one without obscuring it, using opaque colour and a fairly dry brush to produce a distinct surface texture.

Sizing: 'Size' is the agent used to make paper water resistant rather than absorbent. In Turner's time, papers were dipped in gelatine (animal glue) solutions, which sized both sides. See pp.34–5.

Sponging-out: See **lifting-out**.

Stipple: A dotted or spotted effect created using the point of a fine brush.

Stopping-out: A method of retaining highlights by covering or masking the selected area with a masking fluid or 'stopping-out' agent, such as gum arabic. This preserves the appearance of the painted area from subsequent washes. See pp.48, 103.

Texture (paint): Usually refers to the uneven or broken appearance of the painted surface as it interrupts an area of colour.

Texture (paper): The roughness of a sheet of paper as a result of both raw materials and the manufacturing process. The texture of a sheet of paper is its roughness on a macro scale.

Tooth: The tooth of a sheet of paper relates to the roughness of the surface of a sheet and determines how the sheet will interact with applied media. The greater the tooth, the rougher the finish.

Wash: A layer of diluted colour laid down with a brush. A wash can be applied in various forms, including flat, variegated, gradated and wet-in-wet. See pp.43–7.

Watercolour: Pigments, traditionally finely ground, kept in dispersion in water by adding a suitable medium, such as gum arabic. Because of its transparent nature, which takes advantage of the luminosity of white paper, watercolour artists need to work from light to dark, building up to darker tones.

Wove paper: A paper made on woven wire mesh that has an even texture and thickness when held to the light.

Select Bibliography

Anthony Bailey, *Standing in the Sun: A Life of J.M.W. Turner,* London 1997

Peter Bower, *Turner's Papers: A Study of the Manufacture, Selection and Use of his Drawing Papers 1787–1820*, exh. cat., Tate Gallery, London 1990

Peter Bower, *Turner's Later Papers: A Study of the Manufacture, Selection and Use of his Drawing Papers 1820–1851*, exh. cat., Tate Gallery, London 1999

David Blayney Brown, *Turner Watercolours*, exh. cat., Tate Britain, London 2007

James Hamilton, *Turner: A Life,* London 1997

Eric Shanes, *Turner's Watercolour Explorations 1810–1842*, exh. cat., Tate Gallery, London 1997

Sam Smiles, *The Turner Book,* London 2006

Joyce Townsend, *Turner's Painting Techniques* (1993), 4th revised edn., London 2005

Ian Warrell (ed.), Franklin Kelly and others, *J.M.W. Turner,* exh. cat., National Gallery of Art, Washington 2007

Barry Venning, *Turner*, London and New York 2003

Andrew Wilton, *Turner in his Time* (1987), revised edn., London 2006

Contributors

Nicola Moorby is a Curator at Tate Britain where she is currently part of the team preparing the Tate's new online catalogue of the Turner Bequest. In addition to Turner she has previously published on Walter Richard Sickert and is co-author of Tate's catalogue of works by the Camden Town Group.

Ian Warrell is a Curator at Tate Britain, specialising in the works of J.M.W. Turner. As well as co-curating *Turner and the Masters,* he was responsible for the major exhibition of Turner's pictures that toured the USA, Russia and China in 2007–9. His earlier exhibition projects have focused on Ruskin, Blake, the Pre-Raphaelites and nineteenth-century photography.

Mike Chaplin RWS, FRSA, RE, is a renowned painter and has looked intensively at J.M.W. Turner's techniques. He has worked with the Open University filming in the Lake District on Turner and with Tate Britain on several projects including a series of short technical films using pigment from Turner's studio. He gained popular acclaim as the art expert on the Channel 4 series *Watercolour Challenge* participating in more than 60 programmes. He is a member of The Royal Watercolour Society, The Royal Society of Arts and a Fellow of the Royal Society of Painter Printmakers.

Tony Smibert is a full-time painter based in Tasmania and has held more that 40 solo exhibitions worldwide. Current projects include commissions for major corporate collections and research on Turner's techniques at Tate Britain. He is the author of numerous publications and contributes to magazines including *International Artist* and *Craft Arts International.* He teaches watercolour through workshops and digital media.

Jacob Thomas is a Conservation Scientist at the National Museum in Kraków. His research interests include degradation studies of polymeric materials and the preservation of heritage objects through modified atmosphere display and storage. In addition to a background in chemistry, he has studied papermaking at the University of Iowa Center for the Book and International Museum Studies at Gothenburg University. He is also a PhD candidate at UCL, carrying out some of his doctoral research in the Conservation Department at Tate Britain.

Joyce Townsend is a Senior Conservation Scientist at Tate Britain. She specialises in the identification of painting materials and the interpretation of artists' techniques, with an emphasis on appearance change. She is the author of *Turner's Painting Techniques* as well as studies on many other nineteenth-century British artists including William Blake and the Pre-Raphaelites. She has written and edited many books and papers on conservation science and art technological source research.

Rosalind Mallord Turner is a watercolour artist, art researcher and bookbinder. She is a direct descendant of John Turner, J.M.W. Turner's father's eldest brother and inherited the artist's library on the death of her father, C.W.M. Turner. She has transcribed verses for Turner's *Paintings and Poetry* (1990). In 2003 she inaugurated the annual Turner Watercolour Award, which promotes British contemporary watercolour.

Acknowledgements

One of the most exciting things about working on Turner at Tate is the fascination and devotion his work continues to inspire amongst professional and amateur watercolour artists today. This book grew out of an interactive display at Tate Britain, *Colour and Line: Turner's Experiments*, which aimed to explore some of the secrets of Turner's techniques and working methods. A fascinating and crucial part of that story is Turner's use of materials and we are grateful to our colleagues from Tate Conservation, Joyce Townsend and Jacob Thomas, for their expert and insightful contributions. In developing the book's practical exercises we have been privileged to work with two exceptional contemporary practitioners, Mike Chaplin and Tony Smibert. Their knowledge and enthusiasm has greatly enriched our understanding of Turner's approach. We are also extremely grateful to Rosalind Turner for her unstinting encouragement and assistance.

The project presented a number of practical challenges which were overcome due to the expertise and goodwill of a number of our Tate colleagues: Alyson Rolington; Bronwyn Gardner; Christine Kurpiel; David Clarke; Emma Woodiwiss; Joanna Fernandes; Judith Severne; Julia Beaumont-Jones; Lucy Dawkins; Mikei Hall; and Rodney Tidnam. Outside of Tate we have received support and advice from Angela Burman, Vincent Millar and David Newlands. Particular thanks to Simon Elliott and Hayley Kingston from Rose who have worked so hard on the visual layout. Finally, a huge debt of gratitude is owed to the project editors, Rebecca Fortey and Beth Thomas from Tate Publishing. Without their professionalism, vision and dedication the book would not have been possible.

Nicola Moorby and Ian Warrell

Index

Photographic Credits

'You cannot look too much at, nor grow too enthusiastically fond of Turner'

John Ruskin